THIS
FACE
YOU
GOT
THE ART OF THE ILLUSTRATOR

THIS FACE YOU GOT

THE ART OF THE ILLUSTRATOR

Jim McMullan

JOURNEY EDITIONS

Boston Tokyo

In memory of my mother,
Mary Madden McMullan
February 2, 1908 to December 14, 1992

And to the memory of Bob Peak

Published by Journey Editions
an imprint of Charles E. Tuttle Company, Inc.
153 Milk Street, Boston, Massachusetts 02109

Excerpts from "Phizzog" in *Good Morning, America*, copyright
1928 and renewed 1956 by Carl Sandburg, reprinted by
permission of Harcourt Brace Jovanovich, Inc.
Illustration of Carl Sandburg on page vi by Marcia Staimer,
black & white prismacolor, 6" x 4 $^1/_2$, reprinted by permission

Library of Congress Cataloging-in-Publication Data

McMullan, Jim, 1936-
 This face you got : the art of the illustrator / by Jim McMullan.
 p. cm.
1. Celebrities—Portraits—Caricatures and cartoons—Cata-
logs. 2. American wit and humor, Pictorial—Catalogs. I. Title.
NC1420.M36 1994 94-3174
741.5'973—dc20 CIP

ISBN 1-885203-01-2
Design by Michael Snyder
First Edition 1994

Printed in Singapore

Contents

Phizzog

This face you got,
This here phizzog you carry around,
You never picked it out for yourself,
 at all, at all—did you?
This here phizzog—somebody handed it
 to you—am I right?
Somebody said, "Here's yours, now go see
 what you can do with it."
Somebody slipped it to you and it was like
 a package marked:
"No goods exchanged after being taken away"—

This Face You Got.

—Carl Sandburg

PreFACE

precede . . . herald . . . prelude . . .
forerunner . . . precursor

The FACE . . . it goes before us, a harbinger, a messenger—the frontispiece that announces our presence to the world. Like a bowsprit in the wind it says, "Here I am; what you see is what you get."

Almost everyone has something to say about the FACE:

"I never forget a face, but I'll make an exception in your case."
—Groucho Marx

"Your face . . . is as a book, where men may read strange matters."
—Shakespeare

"I have always considered my face a convenience rather than an ornament."
—Oliver Wendell Holmes

"Private faces in public places
Are wiser and nicer
Than public faces in private places."
—W.H. Auden

The visage, the physiognomy . . . it tells all. Our emotions show; our fears, our joys. Poker face or no, it reveals the inner secrets of our soul. The intriguing FACE.

This book abounds with FACES—familiar faces. We are bombarded with them on billboards and magazine covers, on the screen, the tube, on record covers, and posters. Famous faces, bigger than life faces, millions adore their character, elegance, dignity, and wit. We've become enthralled by them and attached to them. They fascinate us with their exalted place in space and time. They have made a mark in the cosmic ledger. Greatness often eludes the great majority of us, so we adore these famous faces, secretly desiring to be like them. We hope that their power and poise will somehow rub off on us. They entertain us, inspire us, preach to us, and guide us.

We sleep with the features of the famous faces in our dreams. We put them on pedestals and praise their deeds and misdeeds. We hire plastic surgeons to mold, manipulate, sculpt, and renovate our own modest mugs to suit the newest, most fashionable look. We want to be like our heroes. What they do is important. We stand in awe, wear what they wear, say what they say, and silently we wish for the success they have. They become our alter egos lifting us out of the ordinary into the sublime.

Perhaps even more than anyone else, the artist finds inspiration in the face. The most fascinating area of the illustrator's world is "face painting" and it takes a very special gift to catch a person's soul in pigment.

Illustration art is created to sell many things: cars, books, politicians, cigarettes, coffee, or jello. Everywhere we turn, we see the illustrators handywork. This book is about the face painters, the "phizzog" lovers who are adept at delineating the faces of the

famous. It is an opportunity to introduce and celebrate the artists who are celebrities in their own field. It is a book about illustrators and their portraits, the illustrators art, and the artists behind the faces.

More than the power of the pen and the airbrush, this book is about the acute perception that the artist brings to the everyday world. These illustrators have lifted these faces beyond what we're used to seeing and into the realm of the humorous, the absurd, the surreal, and sometimes even the sacrilegious.

Each illustrator in this book looks at the face from his own special angle and what he sees is not always what we see. But wheth we are amused, amazed, or horrified v know that we have been touched—for v have taken a new look at the old faces we' often taken for granted, and we'll never lo at them in the same way again.

So step right up ladies and gentlem —faces for sale, all sorts and sizes; fat one lean ones, tough and tight ones, funny one sunny ones, sad and mad ones. Each o unique and special, not one the same. St right up and take a look. I present you with book full of mugs and kissers for your view ing pleasure.

—Jim McMull

oreword

In your face . . . that funny face . . . the ce that launched a thousand ships . . .

It is the one part of the human anatomy at we cannot ignore, and for centuries arts have treated it as their own personal spiration. It has been rendered to the last airy mole. It has been twisted to reveal the ost sinister character flaw. It has been polhed to shine brighter than its reality. And has sold us every product from toothpaste car bodies.

We can keep our mouths shut, our lips aled, our noses to the grindstone and our es on the road and, somehow, an artist will tch enough of a glimpse to recreate us for sterity—or as a horse's posterior.

The treatment of the face by artists goes ell beyond portraiture and, in many ways, e tangents beyond representation are the ost fulfilling for them. The creative eye that n see what's behind the façade and the ility to communicate it through brush and ill are the artist's special gifts. The grosquely toothy grin of a presidential candiate can communicate insincerity. The unting, hollow eyes of the GI with the ",000 yard stare" can communicate battle tigue. The girth of a nose or the shading of e skin can communicate ethnicity. Everying one does to a face in art communicates mething to the viewer.

The contemporary illustrators represented in this book are many of the top talts in a very competitive industry. ustrators make careers from the ability to represent, satirize, or manipulate a face. That is shown here.

A myriad of subjects from the infamous to the mere "15 minutes of fame" variety are grist for an illustrator's mill. That is shown here.

Carl Sandburg intimates that we are given a face and are stuck with it. True. We do try to embellish it with mascara and rouge. We do try to preserve it with a tuck here and a lift there. But, in fact, it does little to the beast. What an artist does with it is lasting . . . just ask Dorian Gray.

Terrence Brown
Director, Society of Illustrators

Introduction

Before photography came into its own, portraiture was the means by which the artist conferred immortality on royalty and popes. As late as the turn of the century when photography did not yet reproduce well by halftone engraving, the artist/reporter drew the faces of leading political luminaries and even those of corpses in the morgue to meet magazine or newspaper deadlines.

Illustrators have always focused on faces, in closeup and in long shots in which they are the picture's center of interest. The success in doing a head has consistently been a good gauge of the artist's overall abilities.

Illustration has historically been the handmaiden of publishing, and it was the newspaper and magazine publishers who commissioned the artists' assignments. Early on, the editors learned from Charles Dana Gibson that a pretty girl on the cover of a magazine sold more newsstand copies; the face of a story's heroine or a picture of a magazine article's protagonist also created more readership. When color printing became possible, Howard Chandler Christy's cover girls made him a celebrity rivalling Gibson. Then along came the Harrison Fisher Girl, the Coles Phillips' "Fadeaway Girl," and the exotic "Benda Girl." Beyond pretty faces, James Montgomery Flagg's incisive portrait sketches recorded everybody who was anybody. He could play it straight or with wicked satire. Neysa McMein drew generic pretty girls for McCall's magazine covers for many years but she also portrayed notable women,

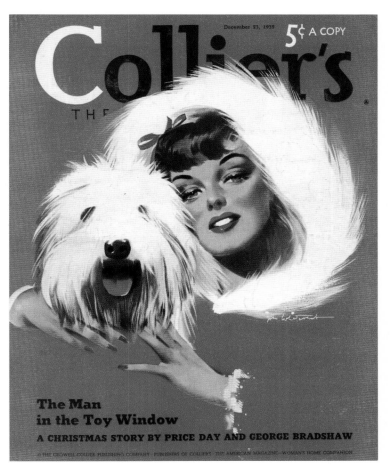

Collier's cover by Jon Whitcomb, 1939

such as Amelia Earhart and Edna St. Vincent Millay.

When advertisers discovered the value of celebrity endorsements of their products, illustration thrived. Norman Rockwell conducted a whole campaign of whiskey ads featuring discerning drinkers that included portraits of his friends, such as fellow illustrator Dean Cornwell. An advertising series by Colgate Palmolive Peet Company followed the birth and development of the Dionne quintuplets over several years through a series of portraits by Andrew Loomis. J.C.

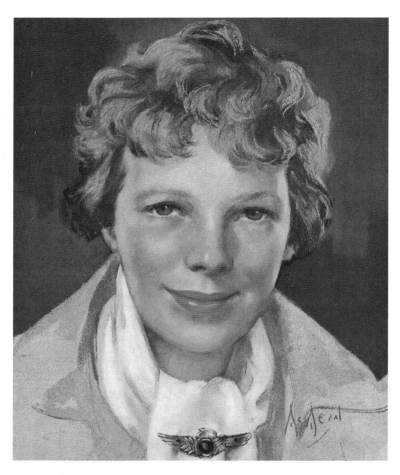

Neysa McMein's portrait of Amelia Earhart, 1937

Some American scenery by James Montgomery Flagg, 1904

Leyendecker was famous for his advertising illustrations for Arrow collars. His male models were so handsome that they generated a lot of fan mail from smitten young women—even proposals of marriage!

Glamorizing the already glamorous became the trend, and even the most beautiful movie stars were further enhanced by artists. Rolf Armstrong added emphasis to eyes and played halos of light on hair and lashes. A whole group of fan magazines, such as *Modern Screen*, *Screen Play*, and *Screen Romances* featured stories on Broadway and film stars, splashing their portraits on the covers. These were often rendered in pastel by artists such as Charles Sheldon—who also did the Breck Shampoo girls—Modest Stein, and Marland Stone. Pastel expert Bradshaw Crandell's work graced the *Cosmopolitan* covers for some twelve years. Jon Whitcomb interviewed movie actresses for *Cosmopolitan*, and also painted accompanying portraits for the interiors or covers.

Movie posters also provided a venue for illustrators, although painting them tended to be a more anonymous specialty (producers did not want artist's signatures competing with the billing of the stars). Some illustrators, among them Armando Seguso, Dan Sayre Groesbeck, and Reynold Brown, were occasionally allowed to sign their work and were well known in the field.

Mid-century, the best showcase for faces was the cover of *Time* magazine. William Oberhardt, who always worked from life, did the first cover featuring House Speaker Joseph Cannon, in 1923. Eventually *Time* developed a warts-and-all look (the artist recorded every pore and hair), in a long dramatic series of newsworthy celebrities. Among the most successful of these artists were Ernest Hamlin Baker, "Giro" (Guy Rowe), and Boris Artzybasheff. Later this group included more diverse artistic interpretations by Réné Bouché, Henry Koerner, Russell Hoban, and many others.

Other news magazines also used portraits of notables, but they were usually more straightforward and literal. Even the staid *Saturday Evening Post* occasionally used portraiture. Norman Rockwell did more than one cover of both presidents Dwight Eisenhower and John Kennedy. He also painted Nixon, Adlai Stevenson, and Lyndon Johnson. Johnson liked his Rockwell visage better than his officially painted portrait by Peter Hurd and emphatically said so.

As the magazines gradually ceded the escapist fiction to television, illustrators did less story illustration and became more focused on depicting personalities. In fact, several fiction illustrators among them Al Parker, Richard Amsel, and Jon Whitcomb, were enlisted by *T.V. Guide* to do covers of

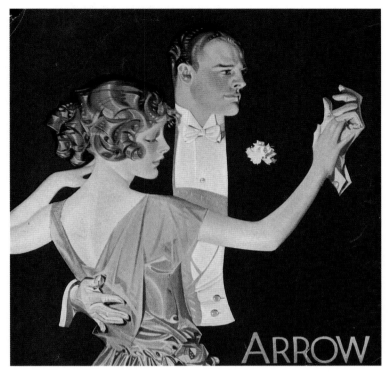

One of J. C. Leyendecker's Arrow collar advertisements, c.1923

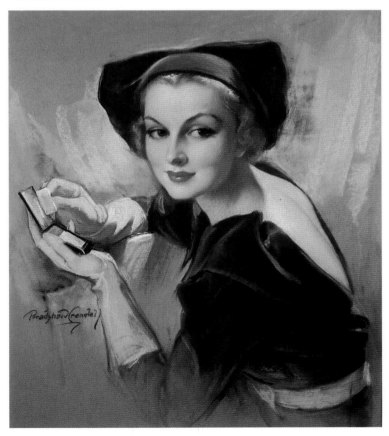

Bradshaw Crandell's *Cosmopolitan* magazine cover portrait of Carole Lombard, c. 1940

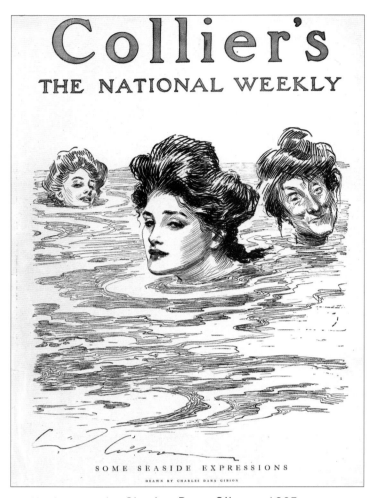

Collier's cover by Charles Dana Gibson, 1905

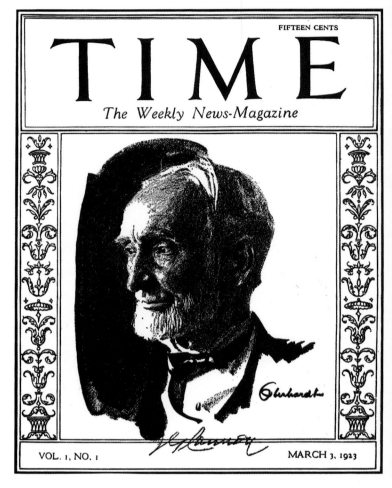

William Oberhardt's cover portrait of Joe Cannon, for the cover of *Time* magazine, 1923

the newly emerging television stars.

Illustrators have not always been kind to their subjects, and caricature has been a favorite feature in many publications, going back in this country to *Harper's Weekly*, *Puck*, *Truth*, and the old *Life* magazine. Favorite targets were politicians, skewered with devastating ridicule by Thomas Nast, Bernard Gillam, and Joseph Keppler, founder of

Puck. Any celebrity was fair game, and *Vanity Fair* frequently published caricatures of celebrities on its covers as well as accompanying the articles inside. Among the best of the regulars were William Cotton, Ralph Barton, and Miguel Covarrubias—the latter turned on his friend Barton with a caricature of the caricaturist. The *New Yorker* had its own cover style but used caricatures regularly for

its "Profiles" feature. Among its contributors were Irma Selz, Eva Herrmann, Alfred Frueh, and William Auerbach-Levy. Sam Berman worked for a host of magazines, including *Fortune*, *Liberty*, *King Features* and *Colliers*, and in every medium.

Caricature as practiced by political cartoonists has developed a graphic shorthand for the most often depicted subjects—particularly the presidents. President Clinton's face has become moon-like—his chin and nose greatly enlarged. A high dome and jutting chin instantly say "George Bush." Teddy Roosevelt showed a huge grin. But the all-time favorite of cartoonists was President Richard Nixon. It is interesting to observe how kindly he was treated at the beginning of his first term but how, as time went on, he became an increasingly malevolent image with a hunched back, heavy brows, and a pinocchio-sized nose. Of course, it helps the artist if the subject has a prominent feature to latch onto, like Lyndon Johnson's big ears, Charles De Gaulle's huge nose, or Mussolini's monumental chin. Dan Quayle may have been an easy verbal target but his even features made him hard to caricature. Generally, women don't take well to exaggeration either. Exceptions have been Golda Meir and Margaret Thatcher. Perhaps, if we get a woman president that will all change.

Contemporary illustrators are now ex-

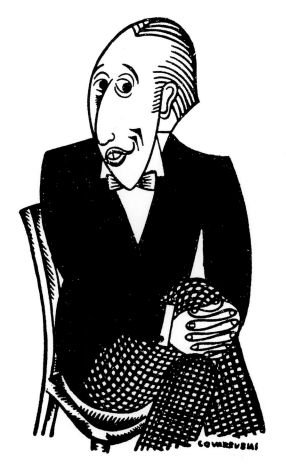

Miguel Covarrubias' portrait of caricaturist Ralph Barton, 1925

ploring every facet of portraiture from outlandish caricature and exaggeration to super-realism. In addition to the traditional mediums, artists are also using anything that can be reproduced, including sculpture, holography, and the myriad effects of the computer. It is an exciting time to be an illustrator—and to view their efforts—as this book amply demonstrates.

Walt Reed

THEMES

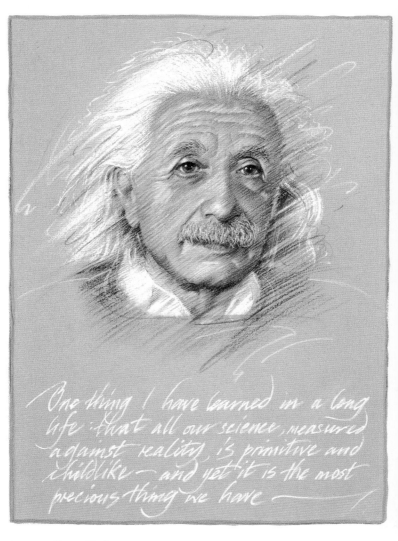

Jacqueline Osborn
pencil
6 ½" x 9"

THEMES

Albert Einstein

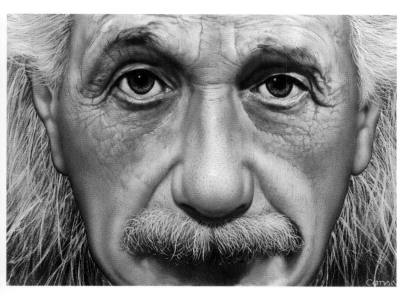

Chris Consani
acrylic
10" x 7"

Jim Evans
enamel on paper
26" x 34"

Mark McIntosh
acrylic and colored pencil
20" x 24"

Richard Thompson
pen and ink
6" x 10"

C.F. Payne
mixed media
11" x 14"

THEMES

Richard Nixon

Barry Jackson
acrylic
30" x 20"

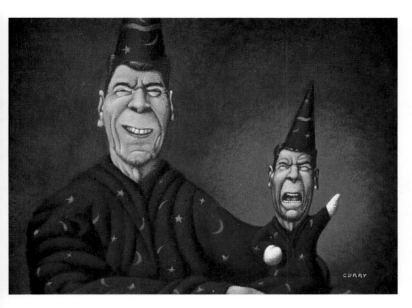

Tom Curry
acrylic on masonite
9" x 7"

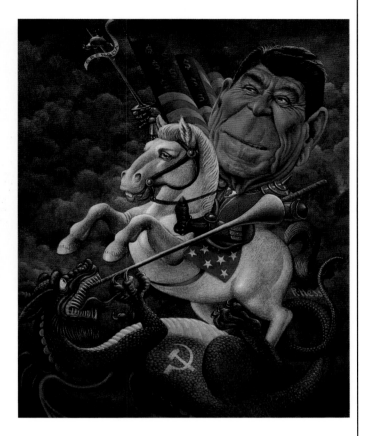

Richard Hess
acrylic
14" x 19"

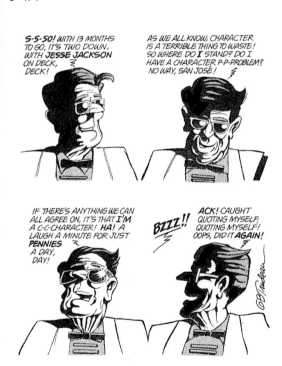

Garry Trudeau
pen and ink
10" x 15"

R o n a l d R e a g a n

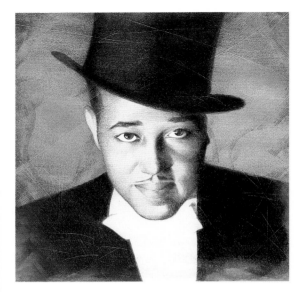

Raul Colón
mixed media
18" x 18"

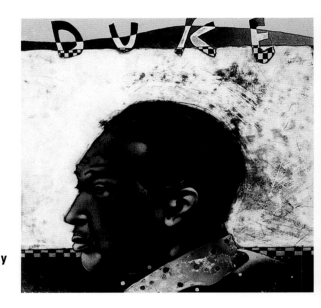

Mark Penberthy
acrylic
24" x 24"

THEMES

Duke Ellington

Rafal Olbinski
acrylic
15 5⁄8" x 27 1⁄4"

6

ILLUSTRATORS

"Fine art" is a very broad area, but basically fine art is making a comment on society, on how society is at the present time. And a good illustrator makes comments continuously about such things, because he or she is taking off from the written work and interpreting it in his own way.

Brian Ajhar

ILLUSTRATORS

Howard Cosell
watercolor & ink
16" x 20 "

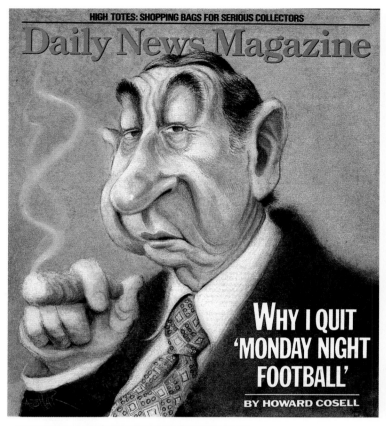

Robin Givens, Ruth Roper & Mike Tyson
watercolor & ink
18" x 24"

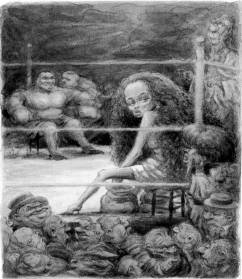

John Updike as Alice's Caterpillar
watercolor & ink
18" x 24"

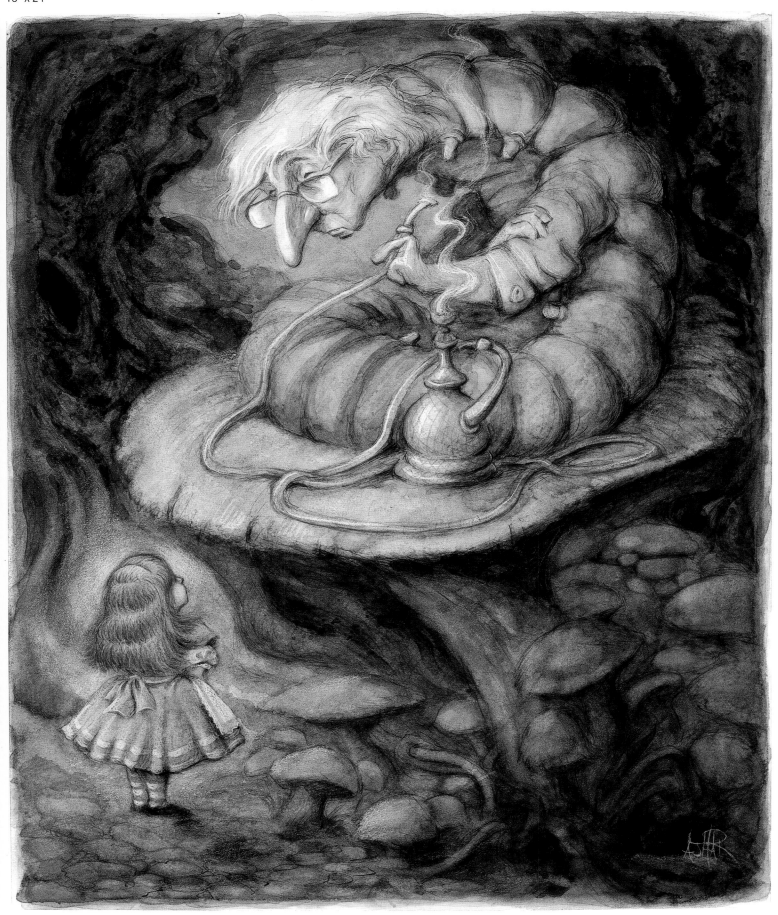

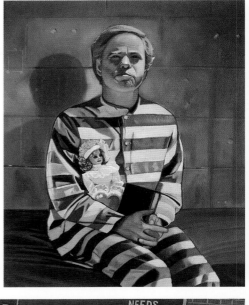

In portraits I am looking for
the emotion. I sometimes find
that my opinion of a person is
revealed to me when the
painting is finished.

Julian Allen ——

ILLUSTRATORS

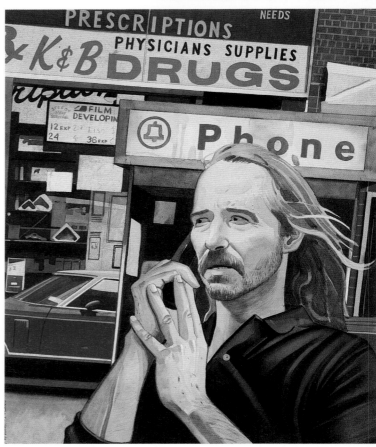

John Phillips
watercolor
15" x 18"

Ross Perot
watercolor
11" x 15"

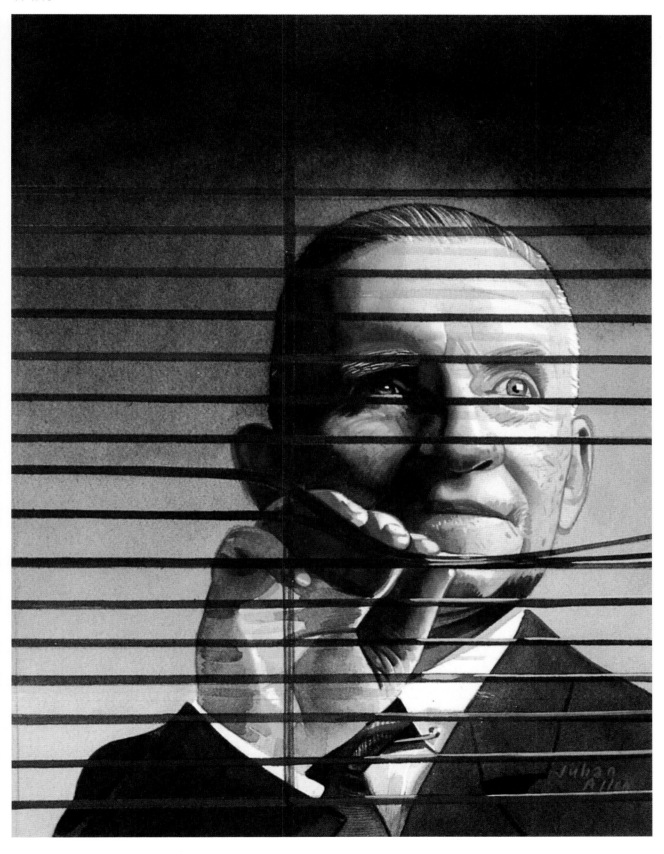

The scratchboard technique gives the image a powerful presence on the page. To be a good scratchboard artist, one must learn to see the interaction between light and shade.

Kent Barton

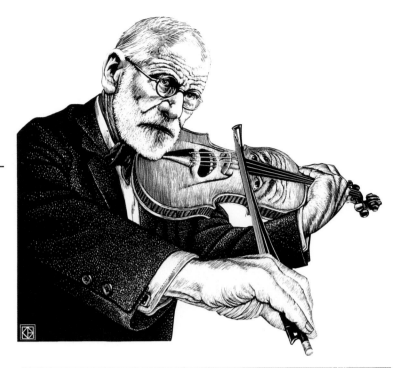

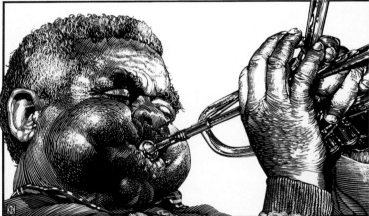

Dizzy Gillespie at the Blue Note
scratchboard
12" x 8 ½"

ILLUSTRATORS

Fidel Castro
scratchboard
14" x 11½"

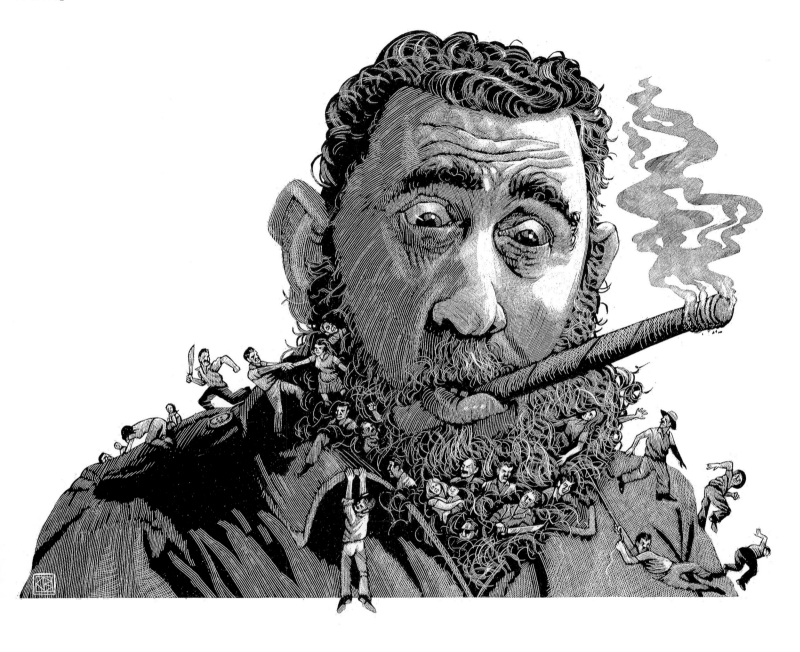

Cum Musis deditus non sim, nosco quod amo. (I don't know much about art, but I do know what I like.)

Pearl Beach

ILLUSTRATORS

Elvis Costello
watercolor
10" x 18"

Nina Simone
mixed media
15" x 12"

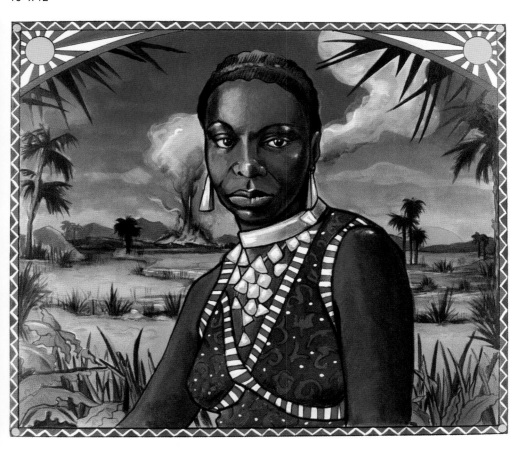

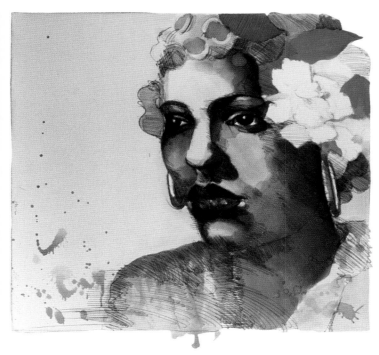

Billie Holiday
watercolor
10" x 10"

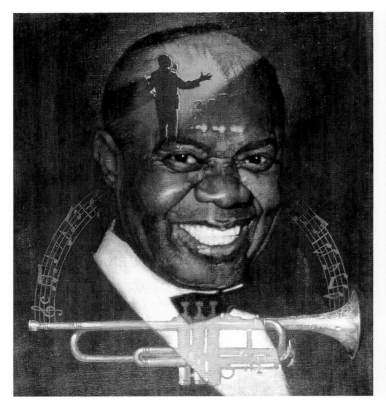

Learn as much as you can, and incorporate it into what you become. Listen to your inner feelings, and have the integrity to stand your ground.

Thomas Blackshear

ILLUSTRATORS

Glenda Jackson
oil
10" x 12"

Martin Luther King, Jr.
mixed media
14" x 18"

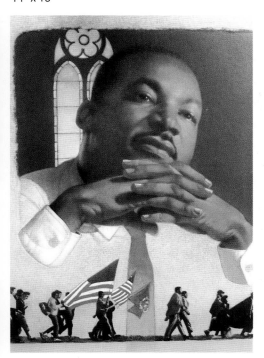

Benjamin Franklin
mixed media
22" x 15"

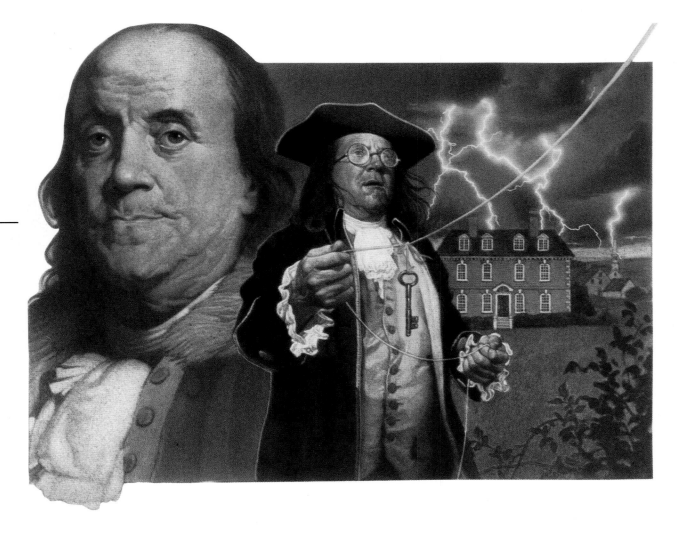

Paul Simon — The Rhythm of the Saints
pen, ink, paper collage
14" x 11"

I ink
therefore I am.

Arnold Schwarzenegger
pen, ink, markers
14" x 11"

Tom Bloom

ILLUSTRATORS

Pablo Picasso, Georges Braque
pen, ink, markers
14" x 11"

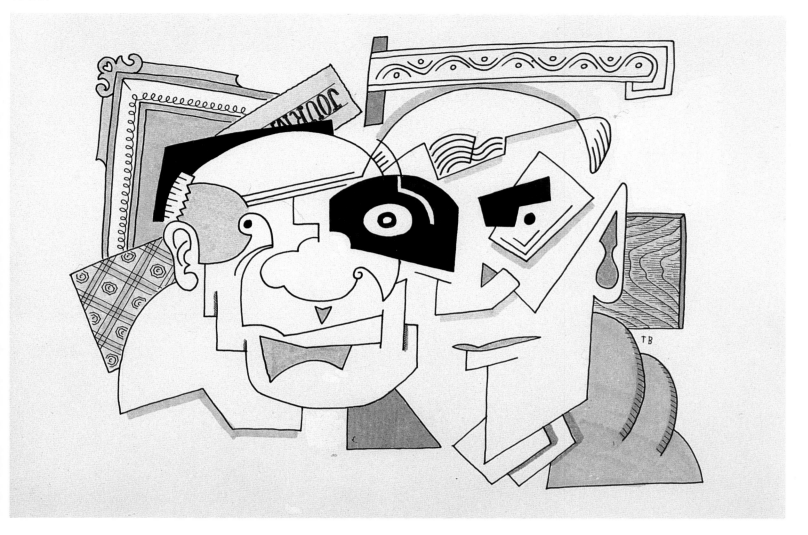

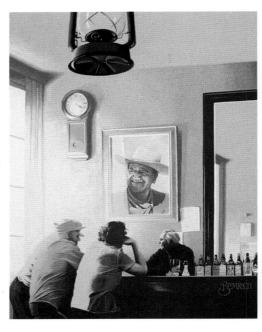

John Wayne
gouache
11¼" x 14¾"

Being inclined toward realism, I do landscapes, still lifes, and portraits. What was fascinating to me was the great difference between illustration and painting in spite of similar materials used: Illustrations are conceived and constructed in a logical way — one is aware of effect. In painting, subconscious response to the subject is brought just close enough to the surface (intention) that it still functions on its own.

Christoph Blumrich

ILLUSTRATORS

Cole Porter
gouache
9 ⅛" x 12¼"

Scott Joplin
gouache
13¼" x 13⅛"

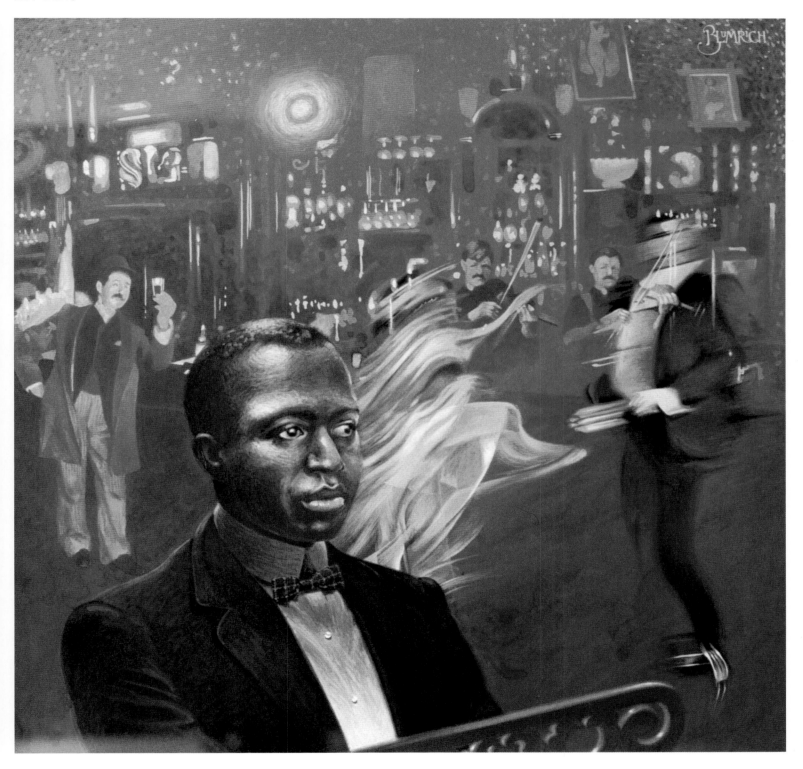

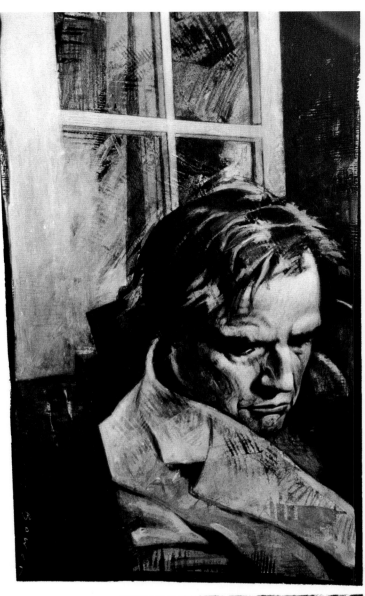

Marlon Brando
acrylic, ink
10" x 14"

It seems (disappointingly) that because of the nature of illustration — deadlines, convenience, budget etc. — pictures are rarely made directly from life, so the illustrator's ideal becomes to invoke feeling through interpretation.

Tim Bower

ILLUSTRATORS

William Faulkner
acrylic, ink
6" x 8"

Virginia Woolf
acrylic, ink
6" x 8"

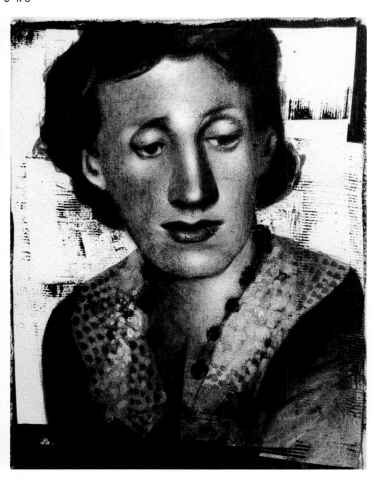

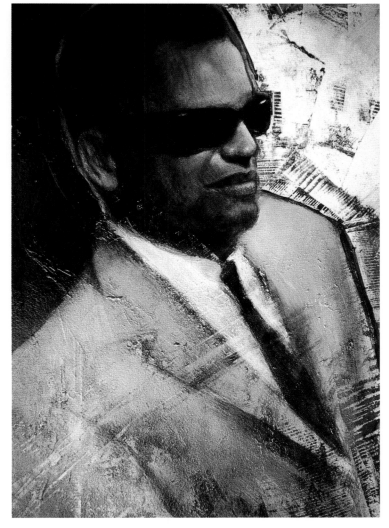

Ray Charles
acrylic, ink
12" x 18"

Satire, which I think I do (I don't know), has a little mean streak in it or at least another level. After you've been amused, or laughed, or smiled, there is a real observation that is not so funny, a center to the picture that is not comical.

Charles Bragg

ILLUSTRATORS

Claude Monet
oil on canvas
18" x 12"

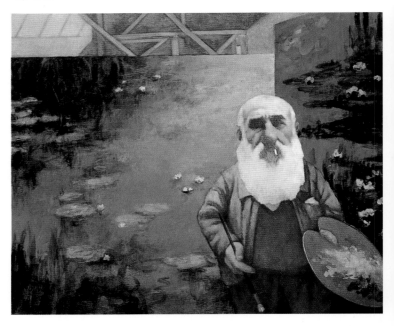

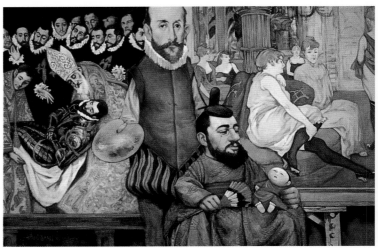

Art Heaven (El Greco, Toulouse-Lautrec)
oil on canvas
36" x 24"

St. Francis of Azusa, 1988
oil on canvas
12" x 12"

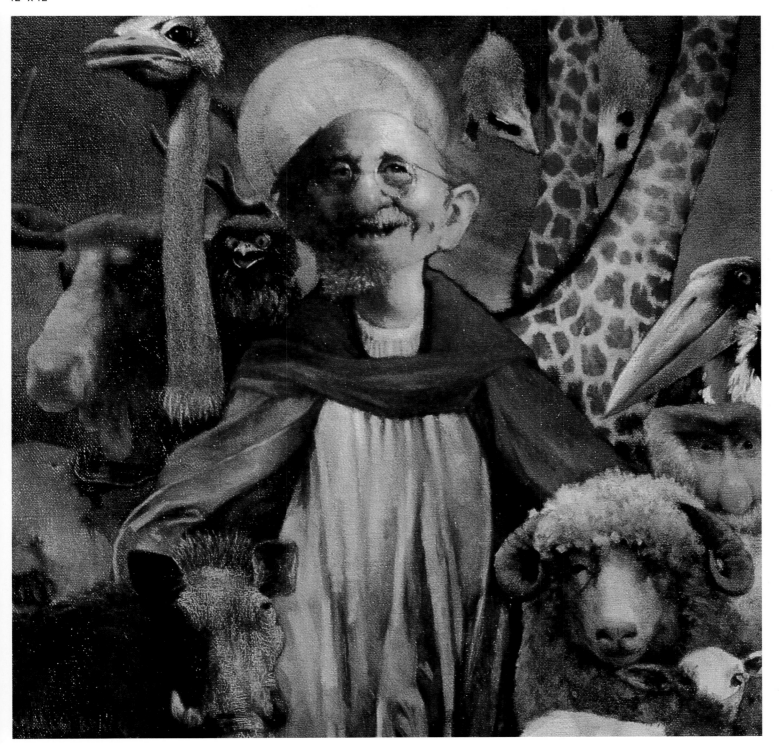

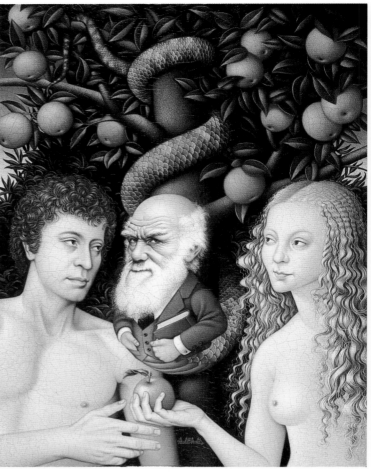

Adam & Eve & Darwin
oil on masonite
14" x 18"

The greatest influence on my work was René Magritte. Magritte's mixture of realism and surrealism played a large role in my evolution as a painter. I think Magritte captured me because he had a these recognizable images tha were strangely juxtaposed in his paintings. That opened a very mysterious door for me.

Braldt Bralds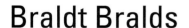

ILLUSTRATORS

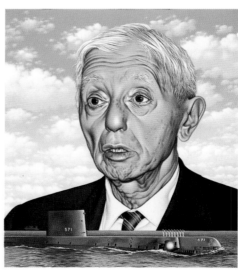

Admiral Rickover
oil on canvas
14" x 18"

President Robert Mugabe
oil on canvas
14" x 18"

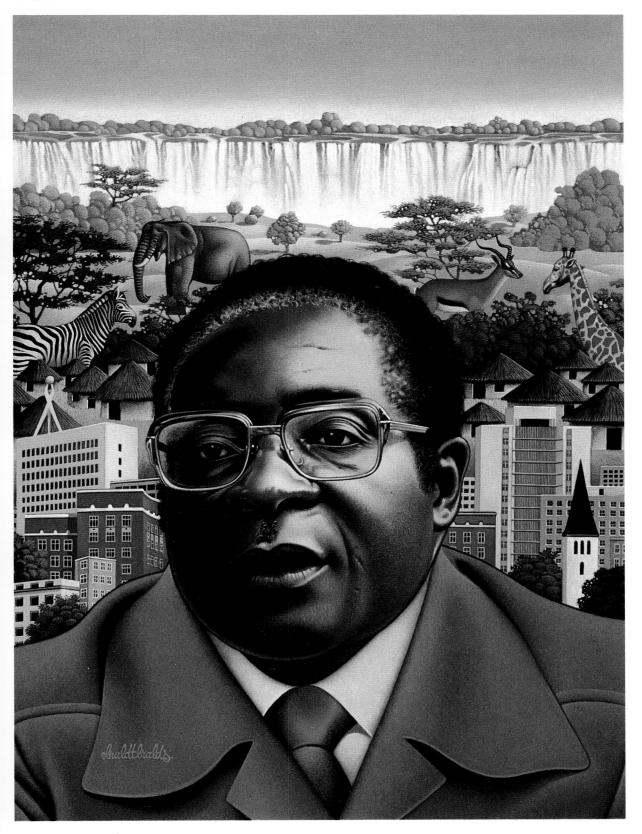

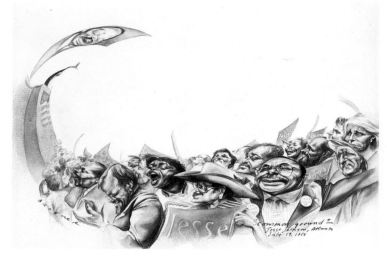

Jesse Jackson "Common Ground," July 19, 1988
pen & ink
20" x 15"

My art is about conceptualization; illustrating ideas (preferably my own). The satire in the art gains its power from the literal point; literal point being made, I almost always see a correlation between a caricature's success and my degree of feeling toward the subject.

Steve Brodner

ILLUSTRATORS

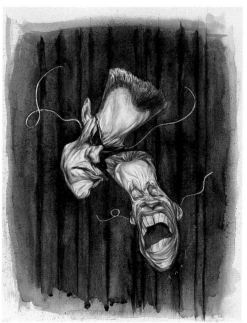

Arnold Schwarzenegger
"Schwarzenegger, Dark & Light"
watercolor
20" x 30"

Jesse Helms
watercolor
15" x 20"

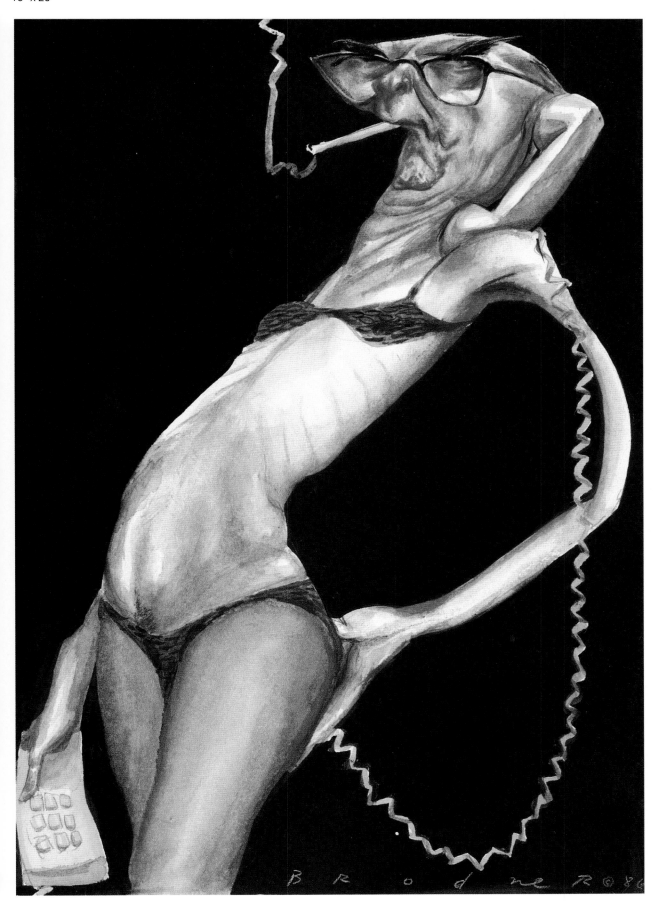

There are very few people who paint a beautiful sunset because they saw one. They paint it because they saw someone else's painting of a beautiful sunset, and were inspired to think about sunsets. You can't be afraid to fall in love with another artist's work.

David Edward Byrd

ILLUSTRATORS

Tom Jones
pencil & ink
9" x 12"

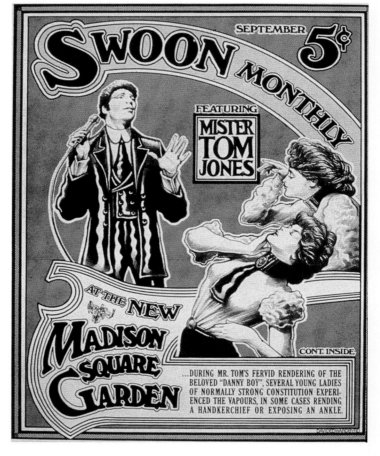

Jimi Hendrix
acrylic & ink
14" x 22"

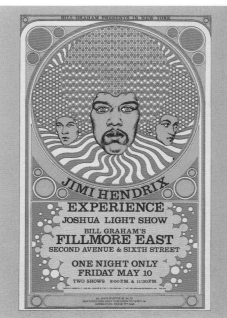

Marco Polo
watercolor & pencil
14" x 17"

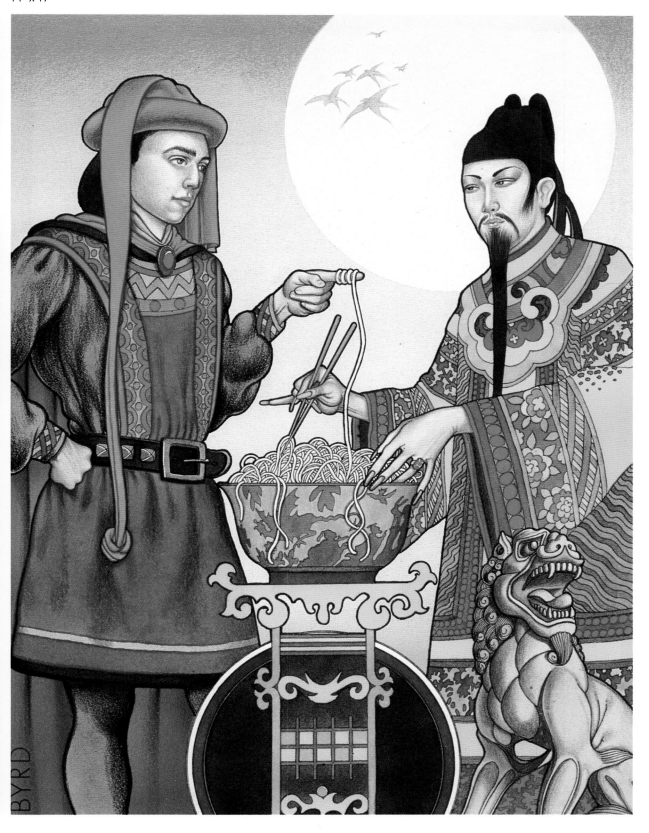

Fidel Castro
mixed media
12" x 16"

I could only be good as a non-conformist. Art has to establish its own order and authority, while attacking the existing one. I have tried to use my assignments as platforms for whatever I have to say, politically, esthetically, or personally.

Seymour Chwast

ILLUSTRATORS

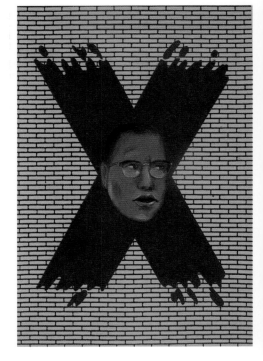

Malcom X
mixed media
12" x 16"

Pablo Picasso
serigraph
30" x 44"

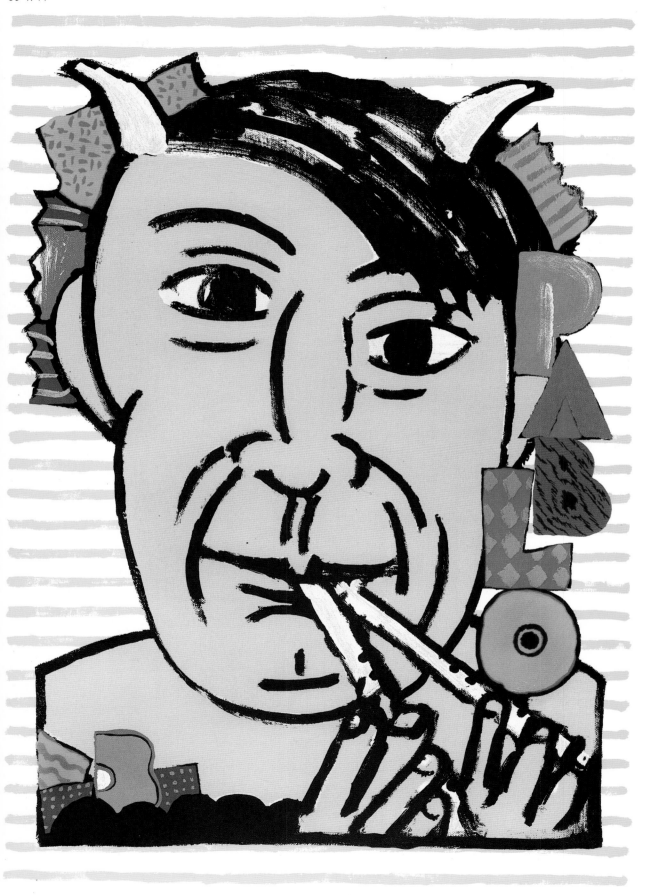

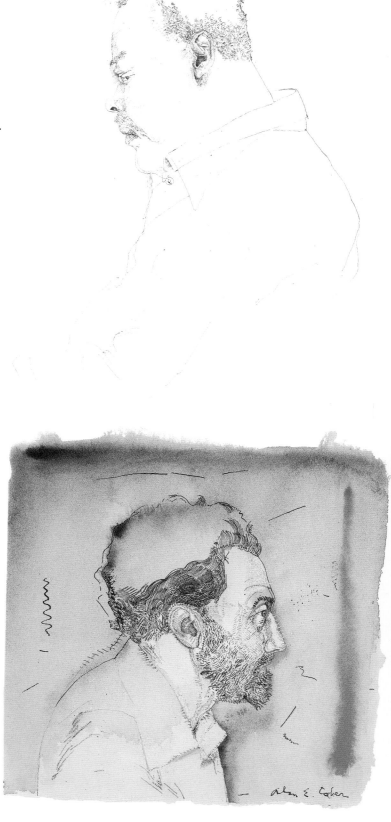

My theory is, everything I do as an artist is a reflection of what I experience in life: the sum of all that experience is what I put on paper. My work reflects who my parents were, where I was raised, what I've read, and whom I've met — everything.

Alan E. Cober

ILLUSTRATORS

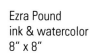

Ezra Pound
ink & watercolor
8" x 8"

Igor Stravinsky
mixed media
17" x 11"

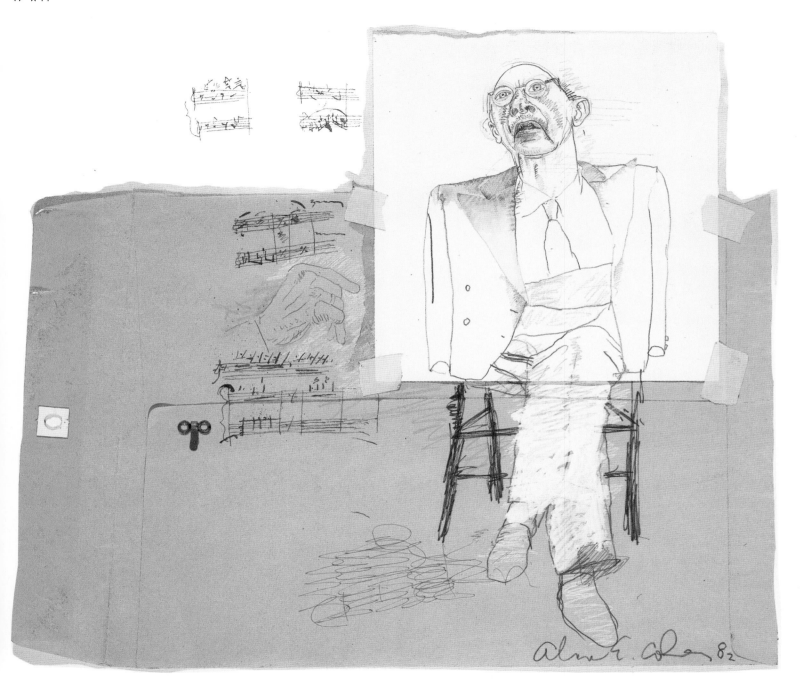

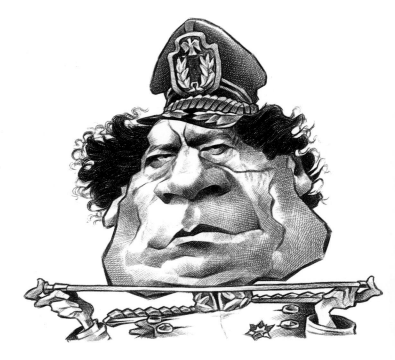

Mu'ammar Qaddafi
pencil
11" x 11"

I feel [my caricatures becoming part of the Knight-Ridder/Tribune Network] is the culmination of events from my high school years on. It is the realization of a goal — I am grateful to have an opportunity to caricature notable personalities and have them reach out to newspapers and magazines around the nation and world.

Ron Coddington

ILLUSTRATORS

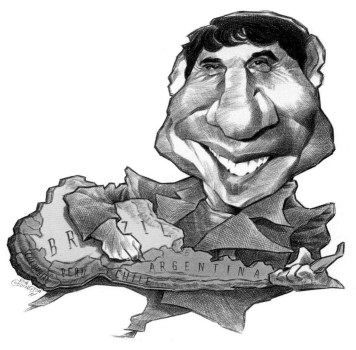

Paul Simon
pencil & wash
13" x 13"

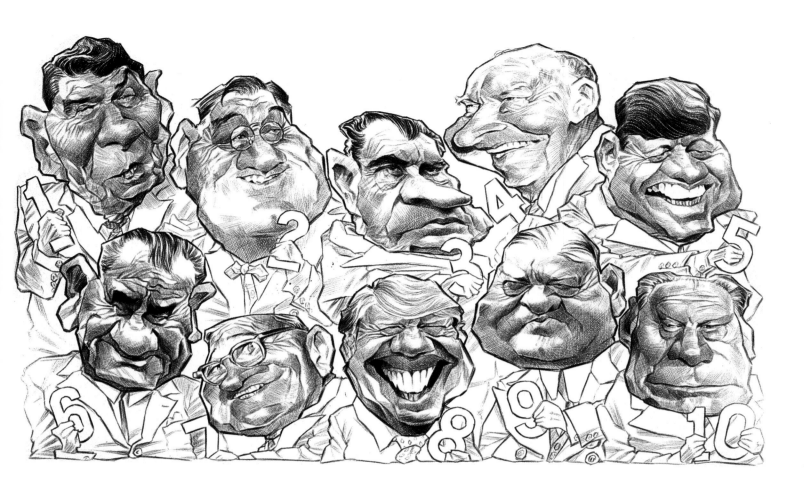

Ten Presidents
 (top row, left to right: Ronald Reagan, Franklin Delano Roosevelt,
 Richard Nixon, Dwight D. Eisenhower, John F. Kennedy,
 Lyndon B. Johnson, Harry S. Truman, Jimmy Carter, Herbert Hoover,
 Gerald Ford)
pencil
17" x 11"

Danny DeVito
acrylic
20" x 30"

I only wish I had eight arms.

Chris Consani

ILLUSTRATORS

Harrison Ford and Sylvester Stallone
acrylic
30" x 31"

Buffalo Bill Cody
acrylic
34" x 24"

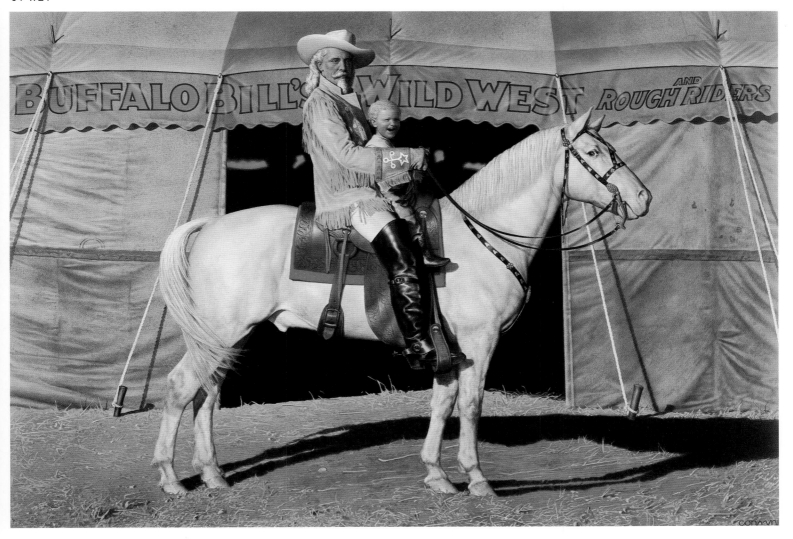

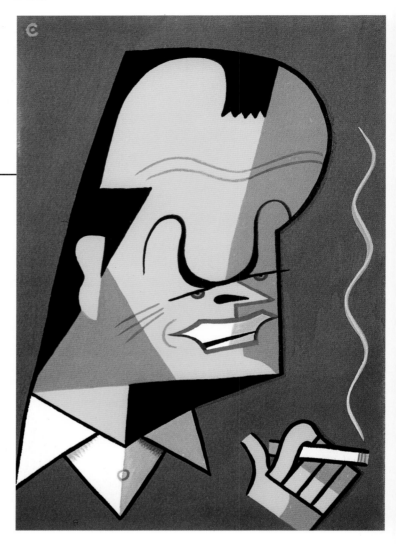

They ask me how I came up with my tongue-in-cheek portraits and I just say, "If you figure it out tell me, and we'll all make some money out of it." Essentially, if he's got a big nose, I just draw a big nose.

David Cowles

ILLUSTRATORS

Michael Jackson
acrylic
8" x 10"

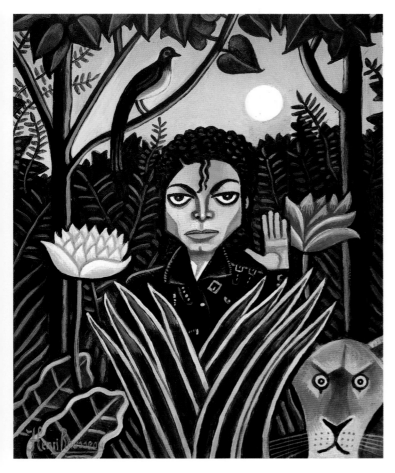

Madonna
gouache
11" x 17"

Sinead O'Connor
acrylic
9 ½" x 12 ½"

Craft believes that she is lucky to have work that is also her hobby, her life. "It is the only thing I have. I just can't do anything else."

Kinuko Y. Craft

ILLUSTRATORS

Bill Clinton
oil on canvas
23" x 29½"

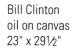

Wolfgang Amadeus Mozart
oil on canvas
20" x 26"

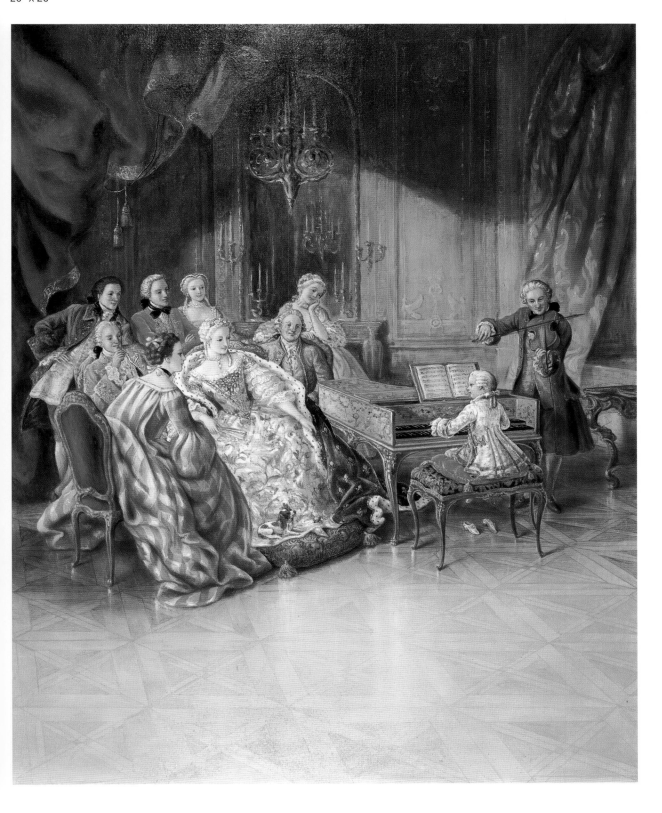

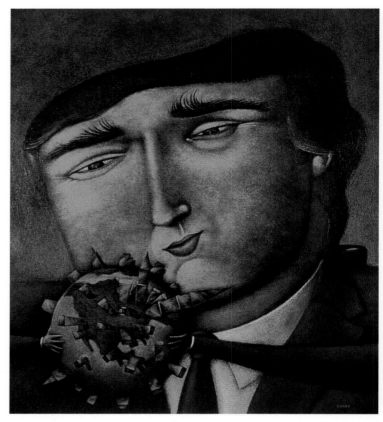

Donald Trump
acrylic on museum board
11" x 13"

I like to approach an assignment from a conceptual point of view, and present the visual in a subtle, humorous but emotionally charged way.

Tom Curry

ILLUSTRATORS

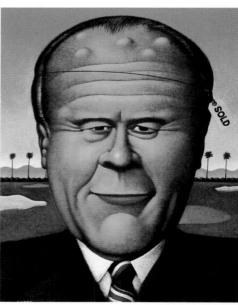

Gerald Ford
acrylic on masonite
11 ¾" x 15 ¼"

Michael Dukakis
acrylic on masonite
6 ¼" x 6 ¼"

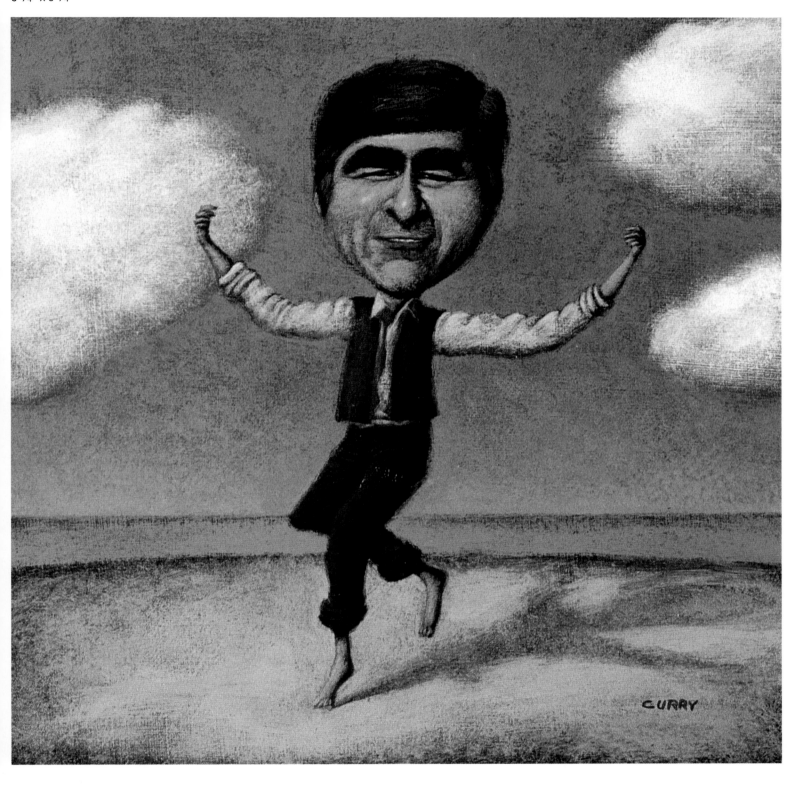

Barry Goldwater
oil
14" x 20"

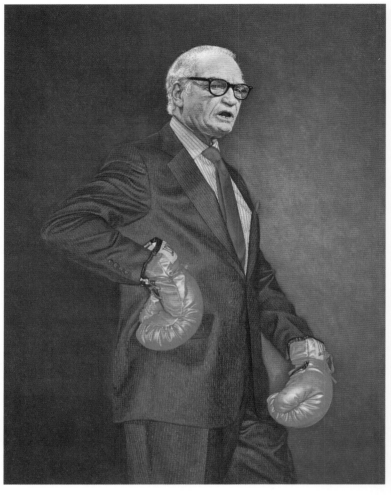

I don't try to change my work. I know it has changed, as has my thinking, but it has never been conscious. I just go on. I'm doing this because I love to do it. And for an artist that's the most important thing.

Herbert Davidson

ILLUSTRATORS

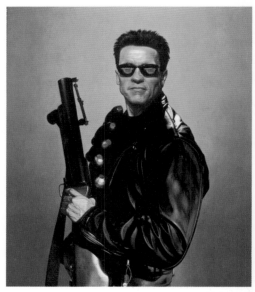

Whatever You Say, Arnold
(Arnold Schwarzennegger)
oil
24" x 30"

Telly Loves Ya! (Telly Savalas)
oil
32" x 24"

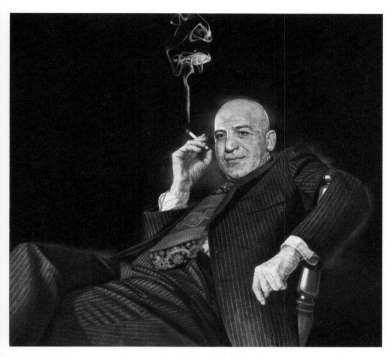

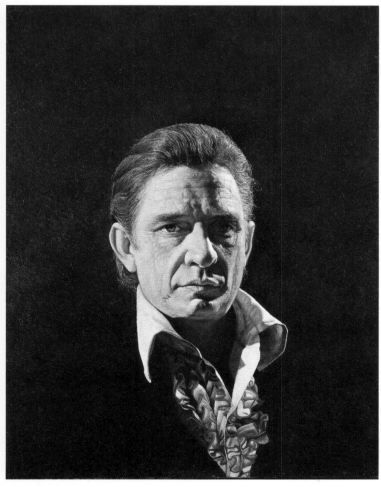

Good Ole Boy (Johnny Cash)
oil
11" x 16"

When you consider that two eyes, a nose, and a mouth in the same basic arrangement are a given, the infinite variety among faces is astonishing.

Paul Davis

ILLUSTRATORS

Garrison Keillor
acrylic on paper
15" x 20"

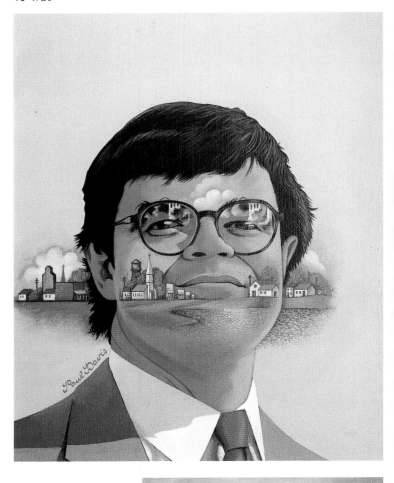

Kevin Kline
acrylic on paper
14" x 22"

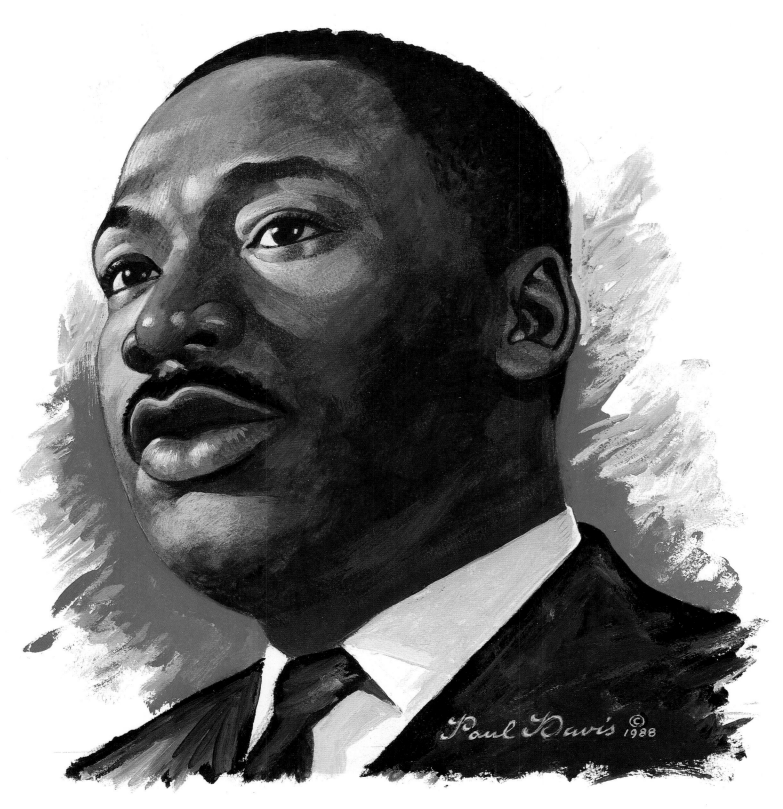

Martin Luther King, Jr.
acrylic on paper
16" x 20"

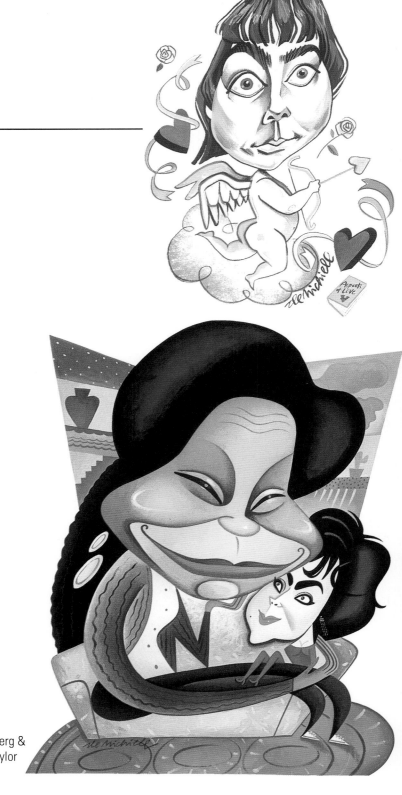

Once, while covering a play for *The New Yorker*, I sat right behind one of my idols, Al Hirschfeld, and thought, I may not be on the level of the greats yet, but at least I'm sitting nearby.

Robert de Michiell

ILLUSTRATORS

Whoopi Goldberg &
Elizabeth Taylor
gouache
9" x 10"

Ella Fitzgerald
gouache
16" x 20"

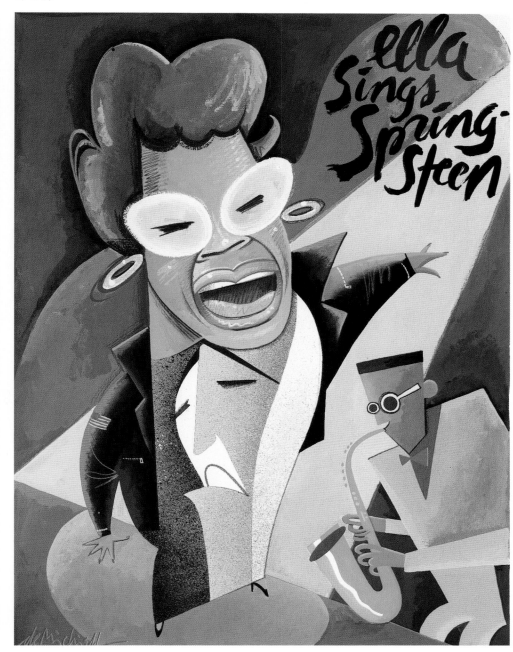

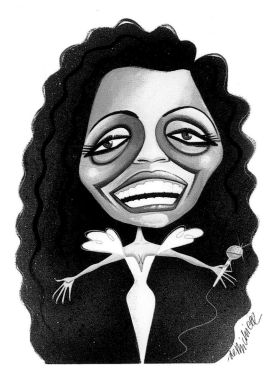

Diana Ross
gouache
18" x 20"

Monk, Coltrane, Bird 'n Diz
watercolor
14" x 11"

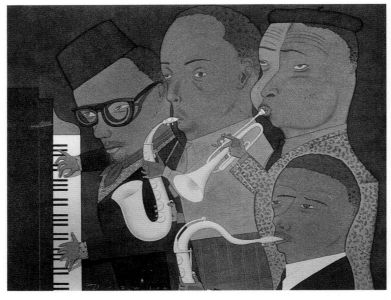

Monk, Coltrane, Bird 'n Diz
watercolor
14" x 11"

Since Darwin and Freud and Marx and Einstein, the condition of modern man seems more and more unintelligible. For every step we take forward in our proud march to an enlightened future, there is an accompanying re-discovery of our underlying savagery. Yet, for all the other things it might be, the human endeavour is a rich and spicy bouillabaisse, giving off flavours deliciously bitter and astringently sweet. More than ever, it comes down to a matter of taste. For the artist, there is plenty to do.

Blair Drawson

ILLUSTRATORS

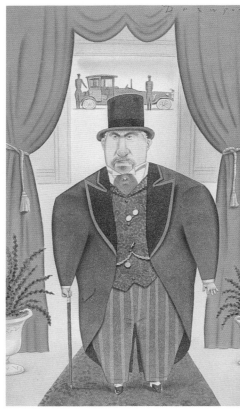

J. P. Morgan
watercolor
10" x 12"

Tina Turner
acrylic
10 ½" x 12 ½"

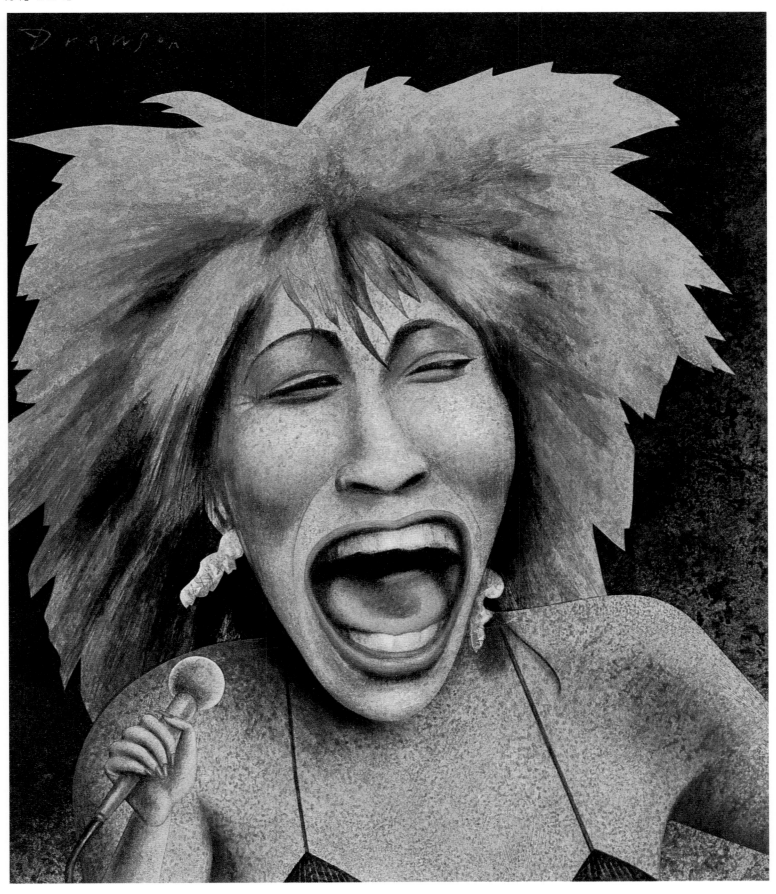

Likenesses are easy
but portraits are difficult.

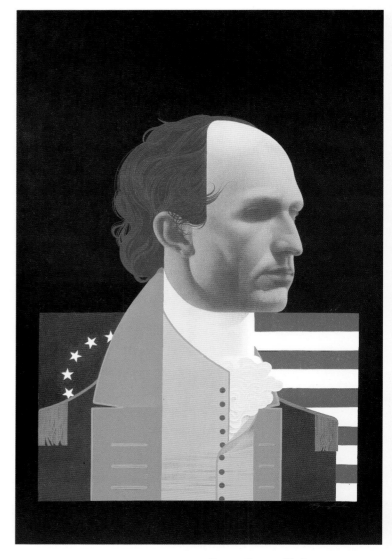

George Rogers Clark
acrylic
30" x 40"

Mark F. English

ILLUSTRATORS

Pierre Auguste Renoir
acrylic
30" x 30"

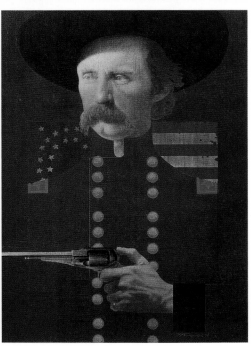

General George Armstrong Custer
acrylic
30" x 40"

Dan Rather
oil on canvas
15" x 24"

I'm an illustrator
and that's that.

Bernie Fuchs

ILLUSTRATORS

Boys of Summer
oil on canvas
50" x 36"

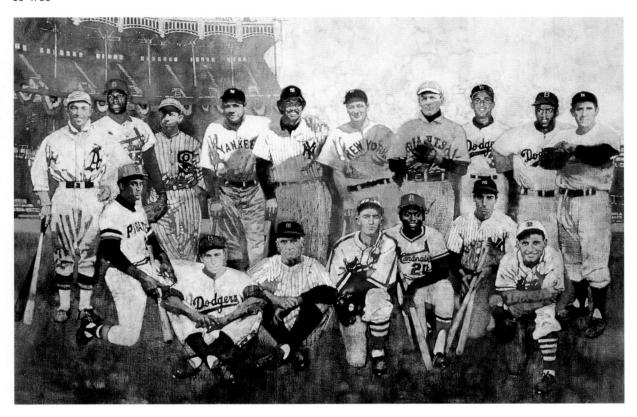

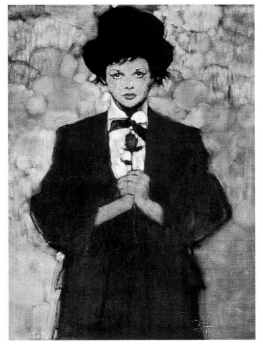

Judy Garland
oil on canvas
15" x 24"

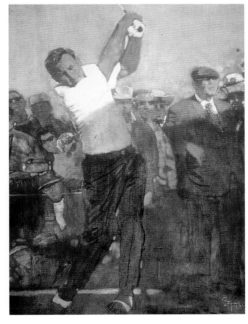

Arnold Palmer
oil on canvas
15" x 24"

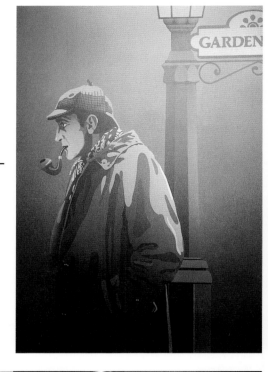

Sherlock Holmes
airbrush & luma dye
11" x 14"

I am not interested in so-called "reality." I prefer the spectrum of all possible realities and the overall structure of an assignment.

Nicholas Gaetano —

ILLUSTRATORS

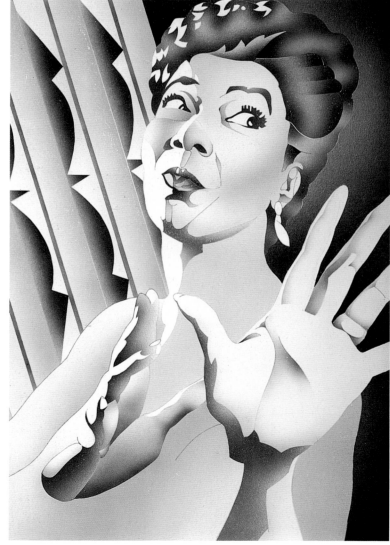

Pearl Bailey
airbrush & luma dye
5" x 7"

Robert De Niro
mixed media
20" x 30"

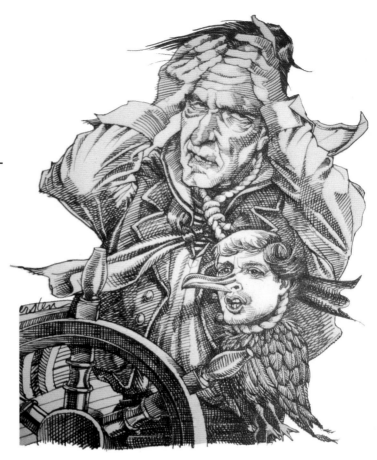

Working in a variety of styles and staying loose is a way of prolonging one's learning period. Comfort in a technique or laziness can get you in a rut Experiment! Don't be afraid to goof a little! Draw a lot. Describe. See and feel even more. Be flexible. Always look for structure and study movies — lots and lots of movies . . . and above all, be curious . . . be passionate!

Gerry Gersten

ILLUSTRATORS

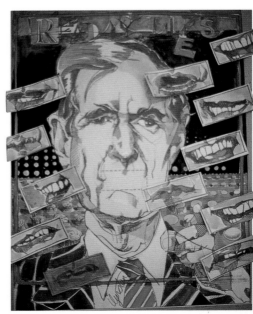

George Bush
colored dyes & gouache on vellum
16" x 20"

Hitler, Lawrence, Hoffman, Napoleon
pencil & dyes on vellum
16" x 24"

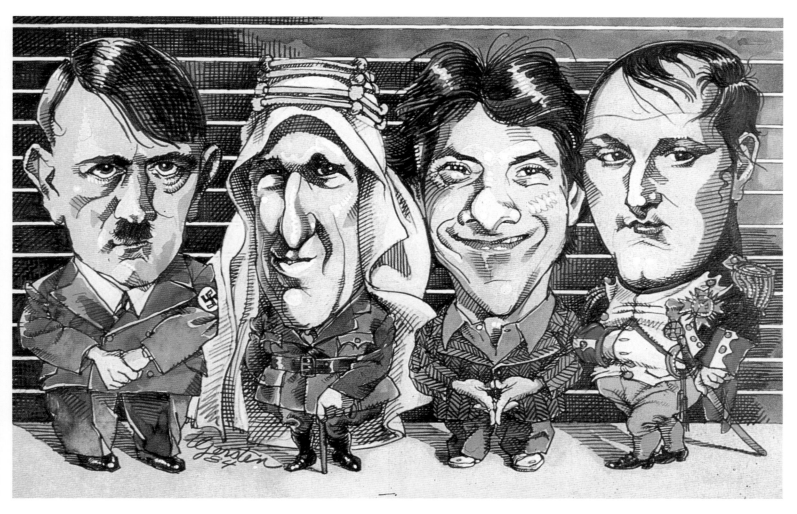

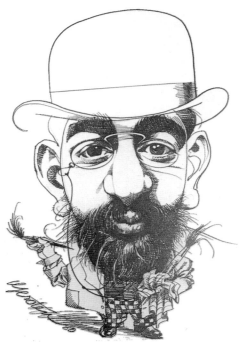

Toulouse-Lautrec
pencil & dyes on vellum
16" x 20"

Dylan
ink
24" x 36"

I create to justify my existence.

Milton Glaser

ILLUSTRATORS

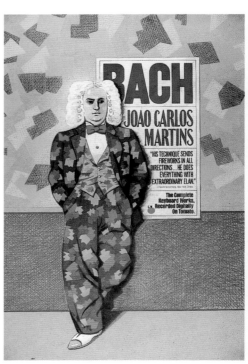
Bach in a Fugue Suit
tempera & wash
24" x 36"

Albert King
tempera & crayon
42" x 63"

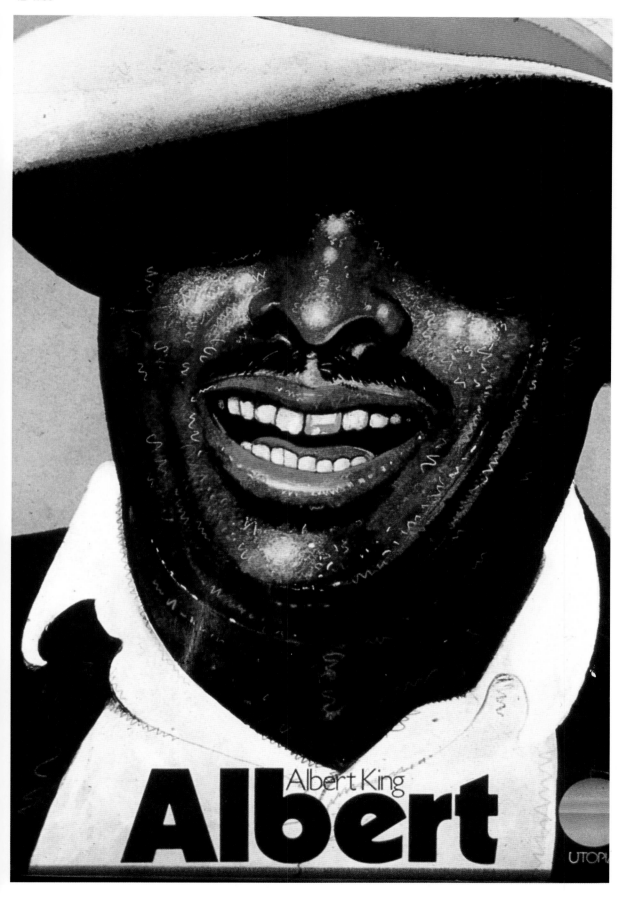

I am the proverbial impish boy, waiting to ambush the rich old gent by throwing snowballs at his big top hat. That's the best we cartoonists can do. We must let the big shots know someone's always out there taking aim.

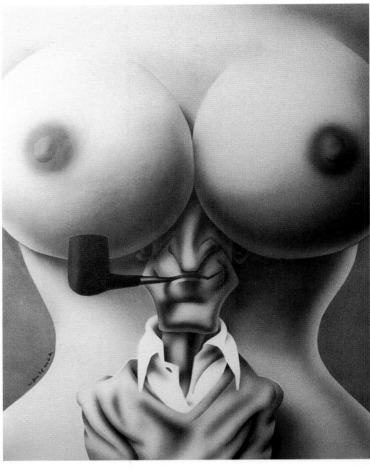

Hugh Hefner
watercolor on board
15" x 20"

Robert Grossman

ILLUSTRATORS

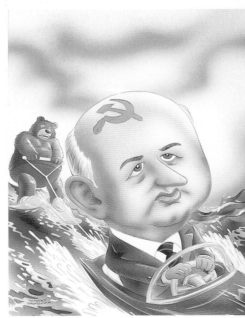

Mikhail Gorbachev
watercolor on board
15" x 20"

James Brown
watercolor on board
15" x 20"

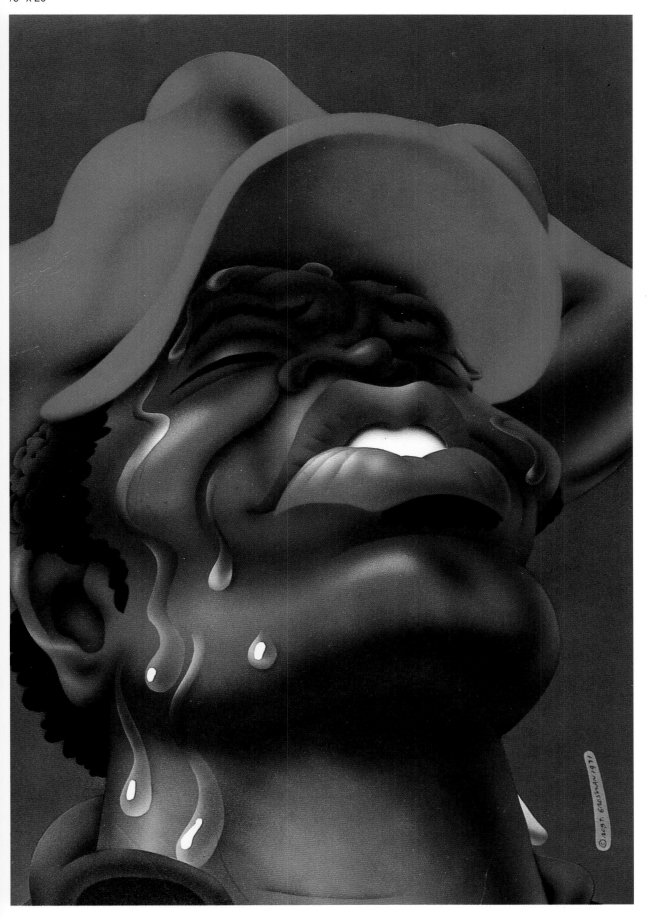

In this kind of work the like-ness must be there but the real assignment is to reveal the character and some aspect of the story.

David Grove ────────

Mel Gibson & Danny Glover
gouache & acrylic on gesso
16" x 24"

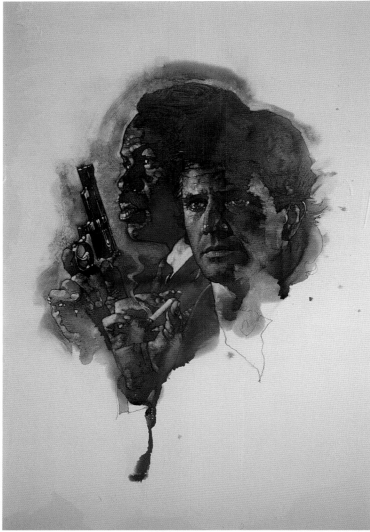

Jessica Lange
pencil on paper
19" x 24"

Diane Keaton
gouache & acrylic on
 gesso
16" x 23"

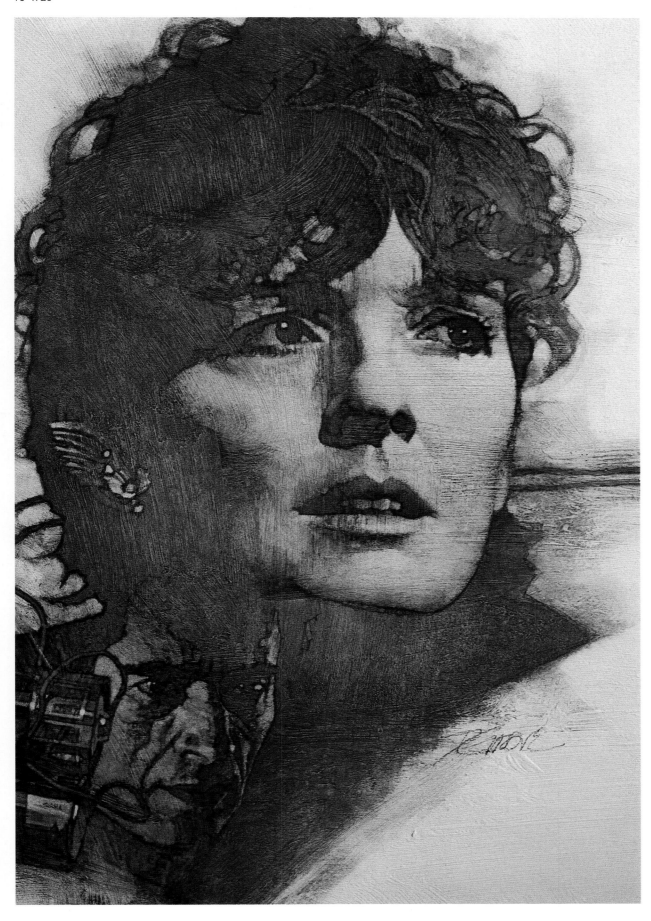

John Belushi
watercolor & colored pencil
18" x 18"

In busy times I eat, sleep, and drink the job at hand. And as soon as I get an O.K. on the direction, I work straight through till I get tired. Then I'll nap a bit, get right back up, eat something, and keep working.

Kunio Hagio

ILLUSTRATORS

Jim Morrison
oil
22" x 28"

John Lennon
watercolor & colored pencil
16" x 20"

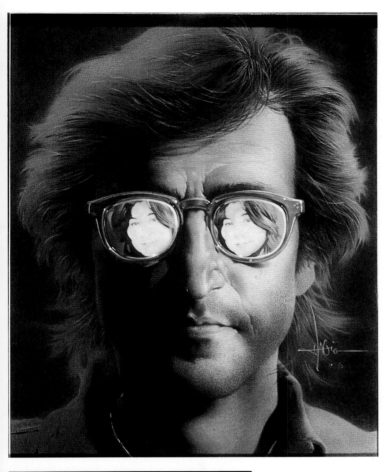

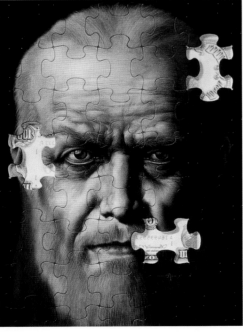

Howard Hughes
watercolor & colored pencil
20" x 30"

Illustration is actually a great life. You can design your own life-style. The rewards of walking by a magazine stand and seeing your cover and knowing that a million people have it on their coffee tables are wonderful. It's communication on a grand scale.

Philip Hays

ILLUSTRATORS

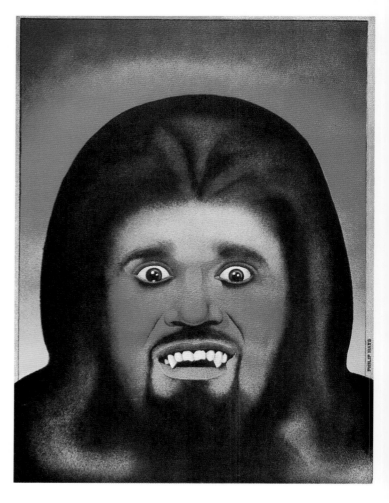

Wolfman Jack
watercolor
18" x 24"

Willie Nelson
watercolor
18" x 24"

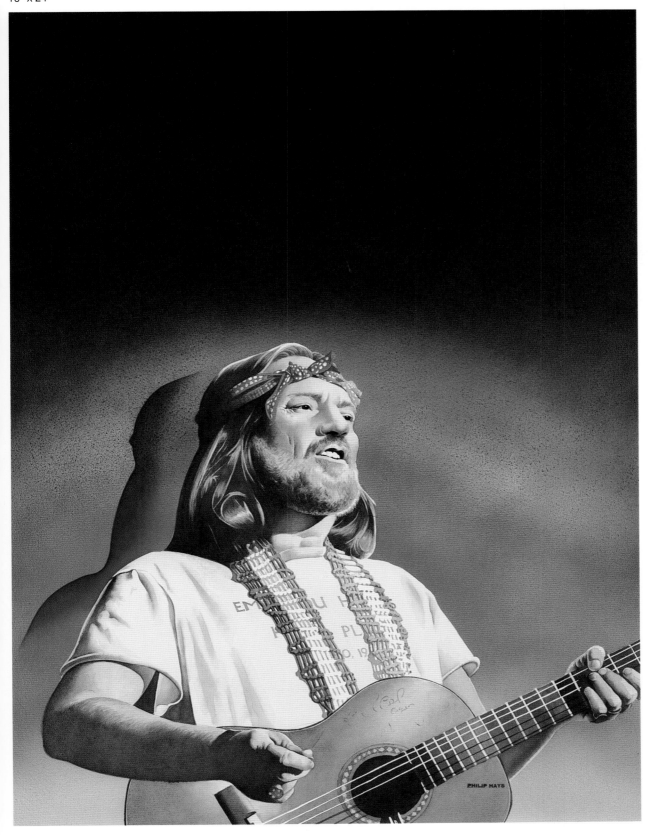

I draw what I see.

Hank Hinton

ILLUSTRATORS

Gandhi
pen & ink
10" x 15"

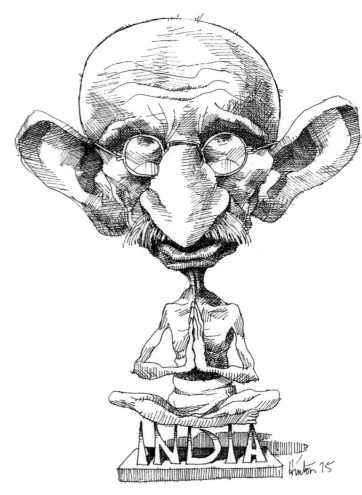

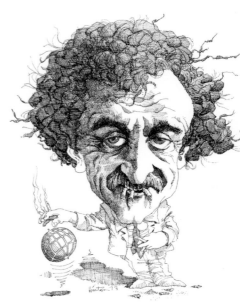

Kurt Vonnegut, Jr.
pen & ink
10" x 15"

John F. Kennedy
pen & ink
10" x 15"

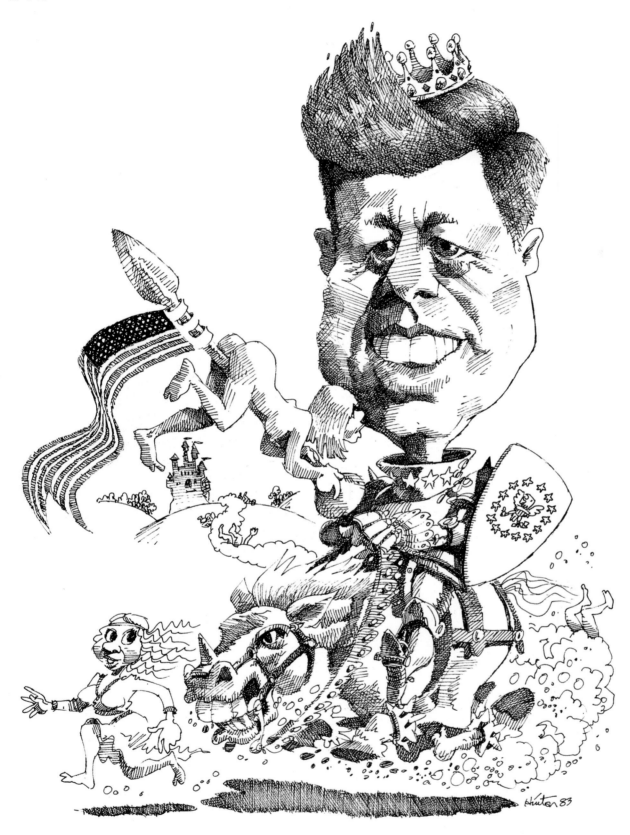

Woody Allen
pen & ink
21" x 27"

When I'm rushed I do a
complicated drawing. It's when
I have the time that I do a
simple one.

Al Hirschfeld

ILLUSTRATORS

Fred Astaire & Ginger Rogers
pen & ink
21" x 27"

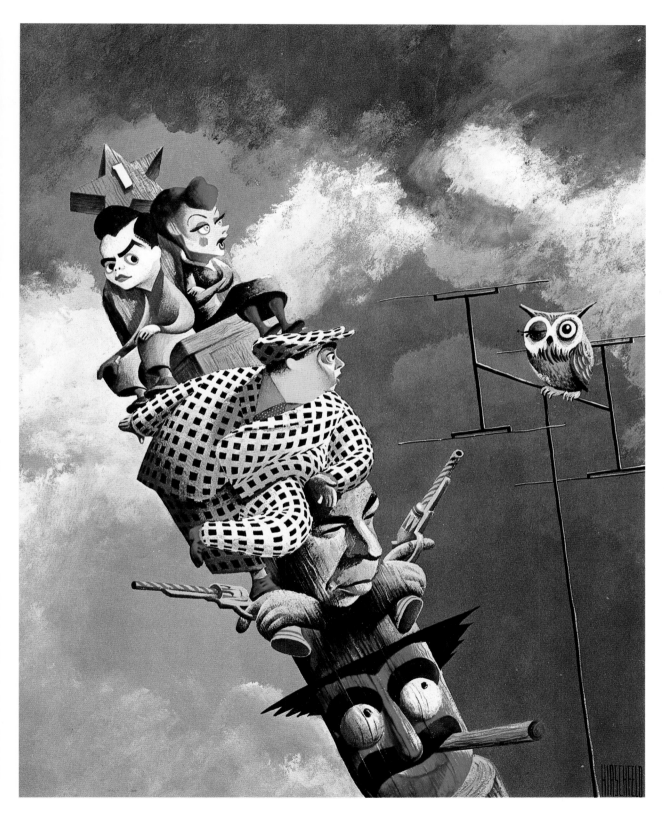

T.V. Totem Pole (Desi Arnaz, Lucille Ball, Jackie Gleason, Jack Webb, Groucho Marx)
gouache
21" x 27"

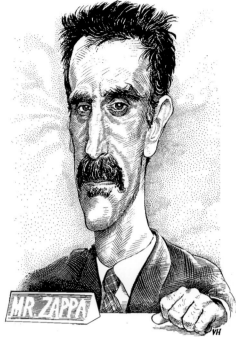

Frank Zappa, the Capitalist
ink & brush
18" x 24"

There's a lot of "method acting" that has to go into a good portrait or caricature. You not only have to fall in love with your subjects, no matter how much you hate them, you also have to try to *become* them, and see the world through their eyes. It doesn't happen every time or even most of the time, which is probably just as well, because it can get pretty weird.

Van Howell

ILLUSTRATORS

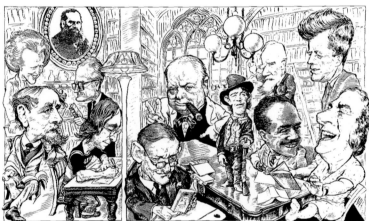

Subjects of Biographies Published in 1988
 (Clockwise from top left: Maggie Thatcher, Fyodor Dostoyevsky (on wall), Barry Goldwater, Winston Churchill, George Bernard Shaw, John F. Kennedy, Golda Meir, Langston Hughes, Billy the Kid (on table), T.S. Eliot, John Lennon, Charles Dickens)
ink & brush
28" x 20"

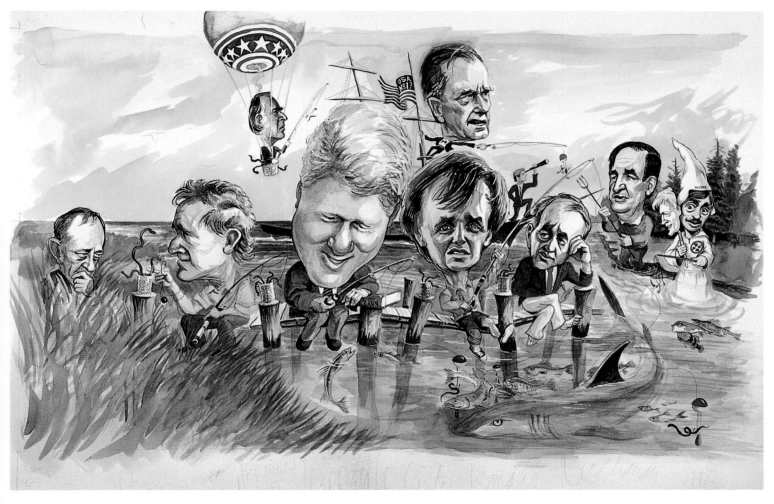

Political Scene in January 1992: Opening Day of a Weird Season
 (Democrats [from Slightly Left to Dead Center]: Mario Cuomo (on sidelines), Tom Harkin,
 Jerry Brown [in sky], Bill Clinton [swelled head, pre-Gennifer], Bob Kerrey, Paul Tsongas.
 Republicans [from Center-Right to Extreme Right]: *On Ship of State:* Captain George Bush,
 Navigator Dan Quayle [observing Mars]; *On Far Shore:* Pat Buchanan, David Duke [new face],
 David Duke [old face].)
watercolor, colored inks
14" x 11"

I like the way I move when I'm drunk.

Barry Jackson

ILLUSTRATORS

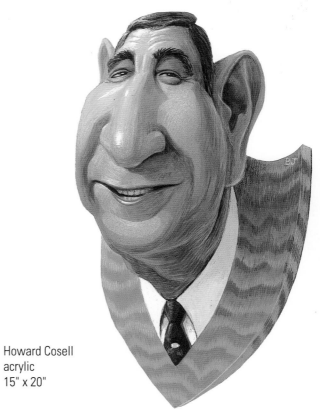

Howard Cosell
acrylic
15" x 20"

ZZ Top
acrylic
50" x 25"

Robin Williams
acrylic
15" x 20"

A caricature is a portrait with the volume turned up.

John Kascht

ILLUSTRATORS

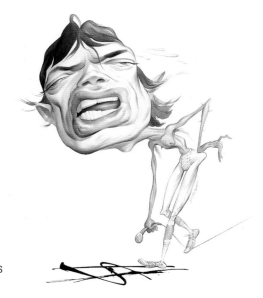

Mick Jagger
watercolor & dyes
16" x 21"

Colin Powell
watercolor & dyes
18" x 22"

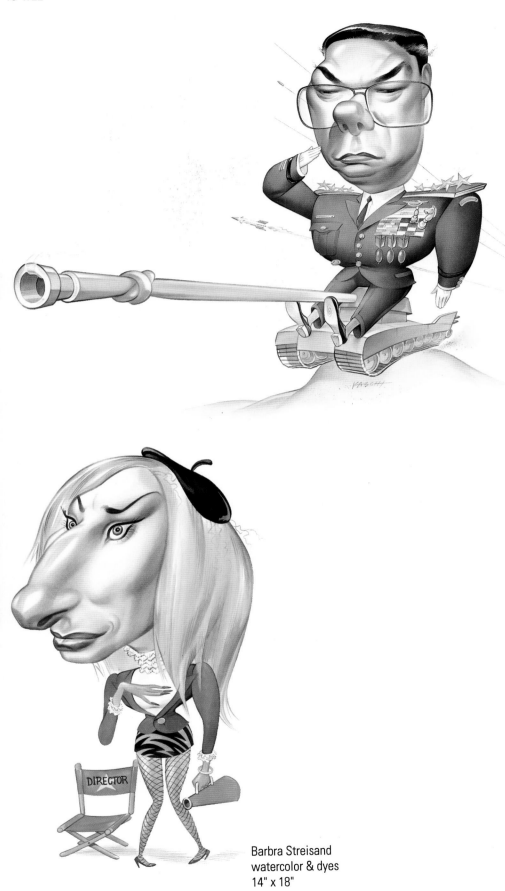

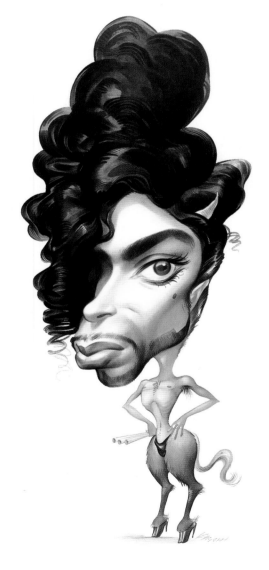

Barbra Streisand
watercolor & dyes
14" x 18"

Prince
watercolor & dyes
12" x 20"

Joe Cocker
pastel
14" x 22"

Although I don't consider myself a portrait artist, the human form is my favorite subject and I find the human face to be the most intriguing and revealing aspect of that form.

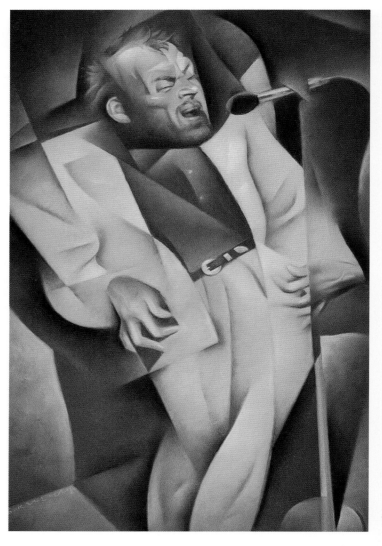

Gary Kelley

ILLUSTRATORS

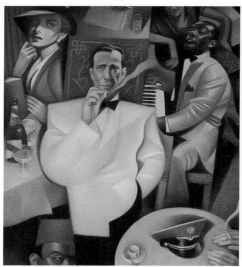

Bogart & Bergman
pastel
16" x 18"

Clapton is God (Eric Clapton)
pastel
18" x 22"

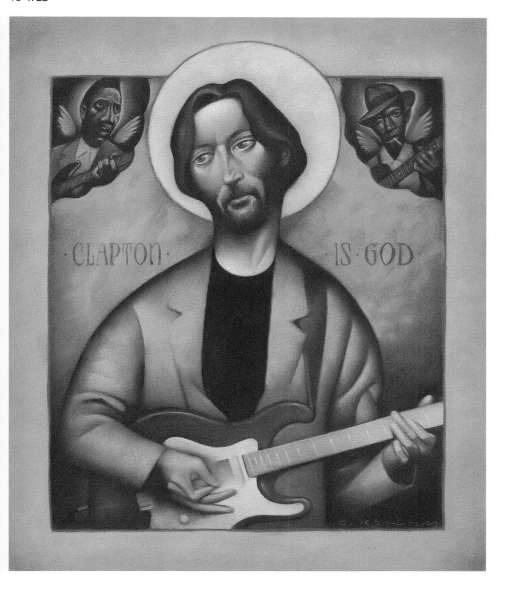

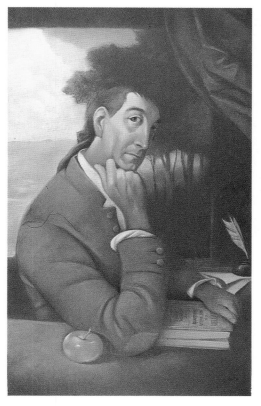

Ichabod Crane
pastel
12" x 20"

George Washington
acrylic
8" x 11"

As an illustrator, my primary objective is to solve the project's visual problems in the most creative manner possible. But, as a secondary goal, I try to create, though not always successfully, a delicate balance between explosion and restraint. Within the image, I allow the explosive force to coexist with the restraining force which seeks to contain and suppress. Humor may come into it at this balance.

Hiro Kimura

ILLUSTRATORS

Miles Davis
acrylic
14" x 14"

"Elvis & Indian"
acrylic
12 ½" x 12 ½"

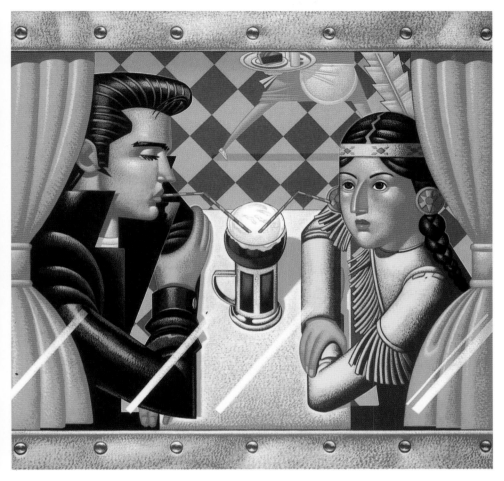

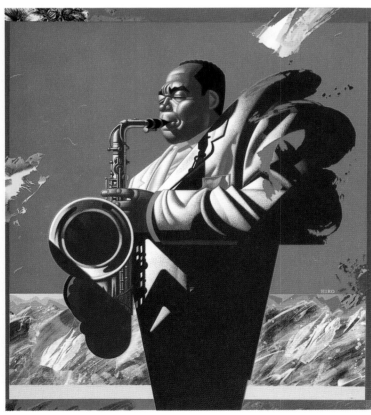

Charlie Parker
acrylic
15" x 15"

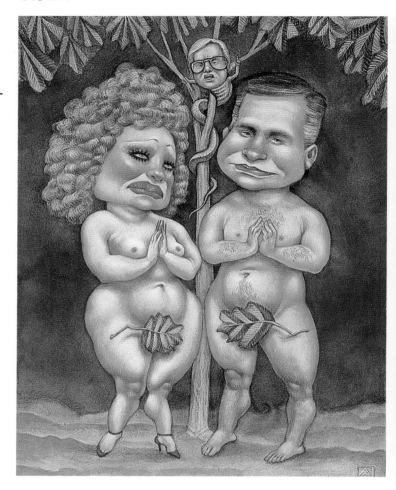

Some people think my work is grotesque; it's not the sort of thing they hang in their kitchens. The distortion of the figures comes from my desire to portray the nature that "keeps man repeating his mistakes." Where a writer can enter a subject and reveal his motivations in the text, in my illustrations I try to make the psychic landscape rise to the picture's surface.

Anita Kunz

ILLUSTRATORS

Sinead O'Connor
watercolor & gouache
10" x 14"

Michael Jackson
watercolor & gouache
10" x 14"

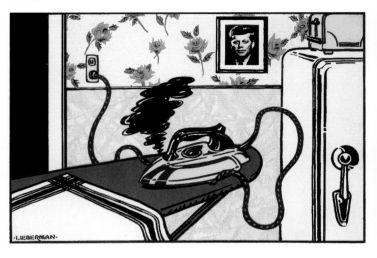

My art is influenced by my love of old postcards, comic books, and old tinted photos from my family albums. I grew up surrounded by icons and tourist attractions and played on the real Monopoly Boardwalk. Lucy the four story high elephant, The High Diving Horse, and Mr. Peanut were all part of my childhood summers in Atlantic City and remain as very strong influences in my graphic art.

Ron Lieberman

Woody Allen
ink & letrafilm
10" x 8"

ILLUSTRATORS

Cathy Chamberlain
mixed media
20" x 30"

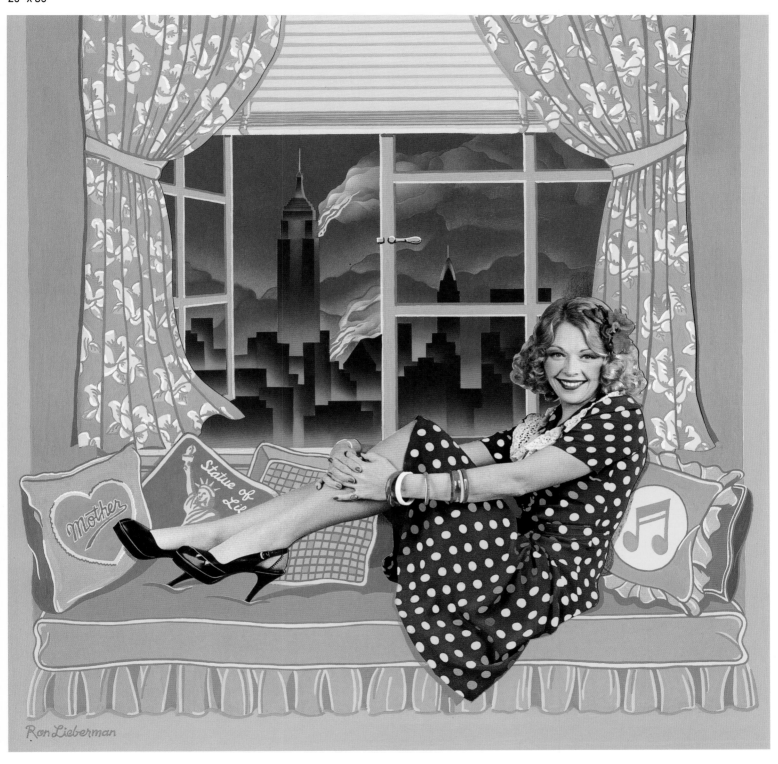

I'm doing exactly what I always wanted to be doing.

Philip Glass
acrylic
9" x 12"

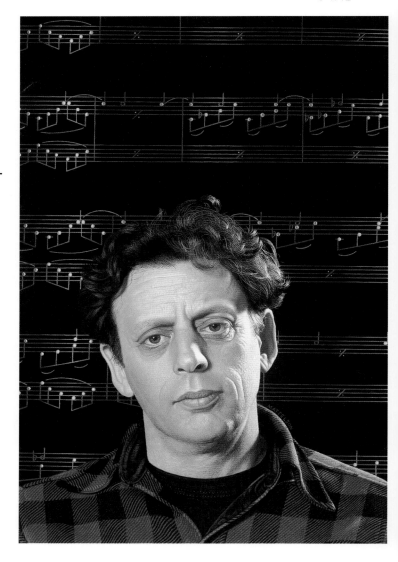

Marvin Mattelson

ILLUSTRATORS

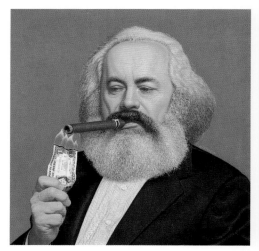

Karl Marx
acrylic
9" x 9"

Peter Schickele/PDQ Bach
acrylic
12" x 12"

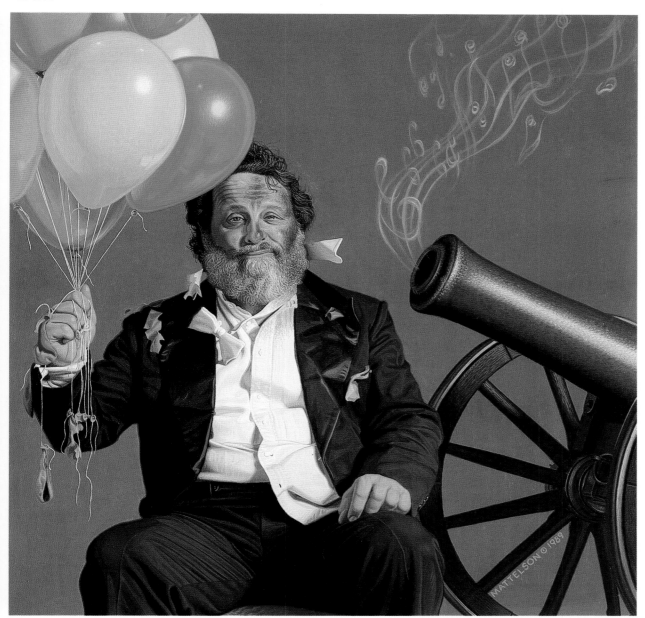

Jeff Daniels
acrylic
10" x 10"

Philadelphia Flyers
acrylic
30" x 20"

To reinvigorate and continue
to evolve as an artist, side-
stepping the pitfalls and traps,
i.e., trappings, is necessary.

Wilson McLean

ILLUSTRATORS

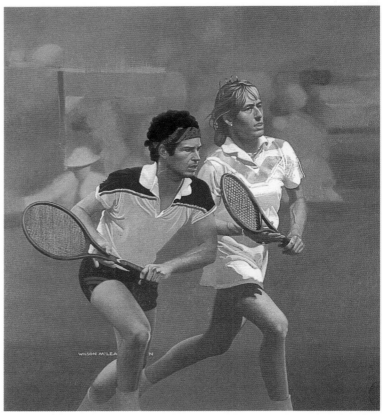

McEnroe & Navratilova
oil
16" x 18"

Lenin
oil
20" x 16"

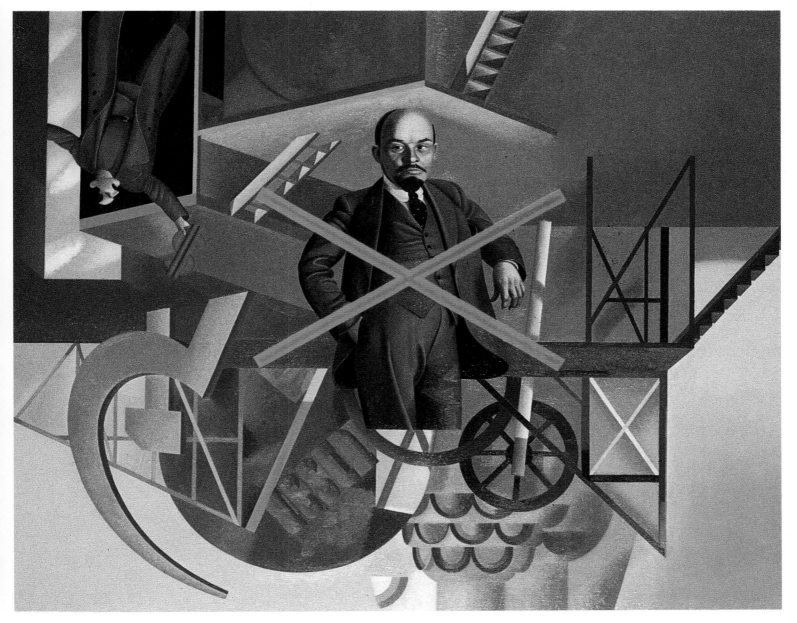

Lorne Michaels
wash & airbrush
9" x 12"

David McMacken's advice to aspiring artists is simple: "Find a couple of friends with similar interests, go to a city, rent common space, join the Design Guild and the Society of Illustrators, go to meetings, plug into everything that's happening and before you know it, you'll have all the work you want. Of course that is contingent on one thing — talent."

David McMacken

ILLUSTRATORS

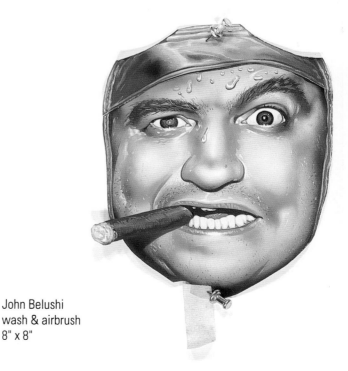

John Belushi
wash & airbrush
8" x 8"

Robert Mitchum &
 Charlotte Rampling
acrylic & airbrush
30" x 40"

Degas Emerging from a Pissoir — Etude in Greys
oil on canvas
45 ½" x 43 ½"

My desire is to know and celebrate people and events that others find devoid of significance. More often than not these esoteric fragments of "public information" reveal my taste for the bizarre or darker side of human existence.

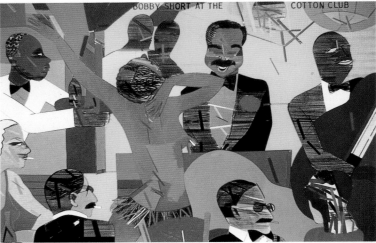

Bobby Short at the Cotton Club
tempera on board
72" x 48"

Richard Merkin

Los Hermanos Marx at L'Ecole des Filles
oil on canvas
43 ½" x 45"

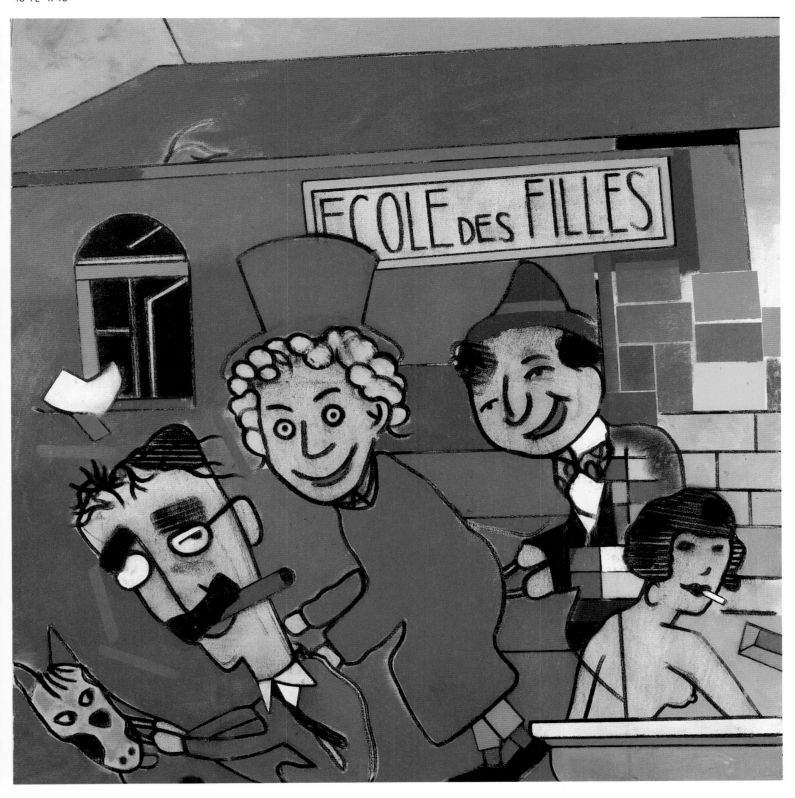

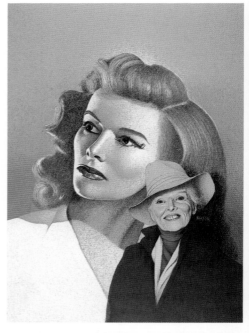

Katharine Hepburn
colored pencil on
matte board
15" x 19"

My illustrations have always explored the human form and the way light accentuates and bathes it. When individual forms are lit properly, they intrigue me. I can become totally absorbed with an elbow or a shoe, forgetting there is more to illustrate before I'm through.

Bill Nelson

ILLUSTRATORS

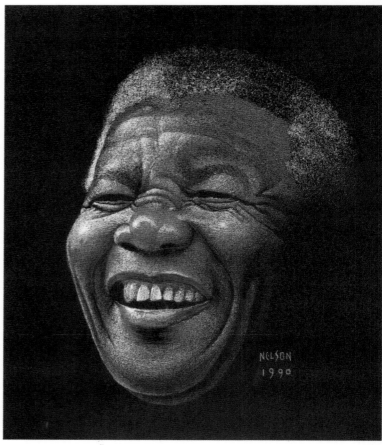

Nelson Mandela
colored pencil
10" x 15"

The Marx Brothers' Lost Radio Show
colored pencil on canson paper
9" x 14"

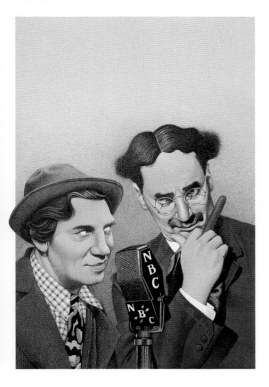

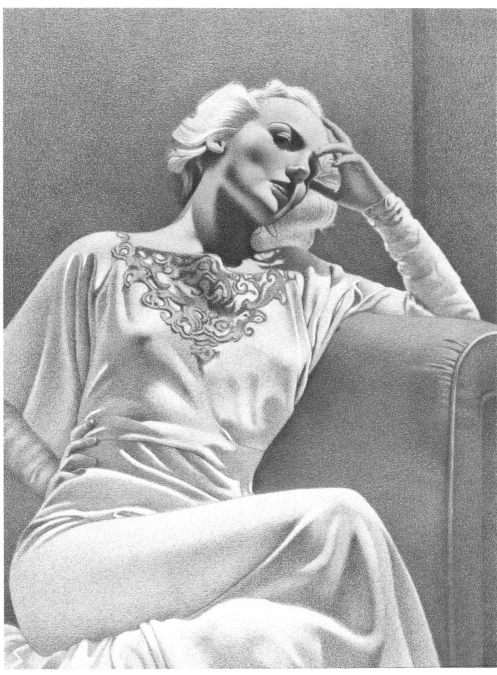

Carole Lombard, 1936
colored pencil on canson paper
9" x 12"

Drawing and painting are not
something you just do . . .
they're something you live!

Craig Nelson ────────────

ILLUSTRATORS

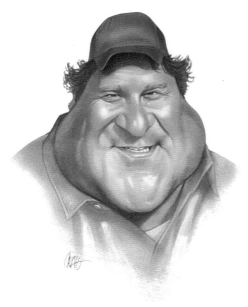

John Goodman
charcoal
11" x 14"

David Carradine
acrylic
30" x 40"

George Bush
mixed media
11" x 14"

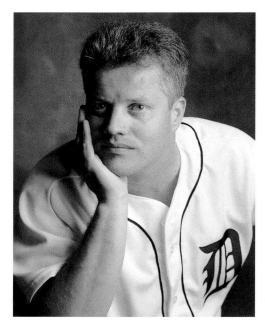

I consider it a privilege to be able to draw and paint the way I did as a kid . . . the only difference now is that my supplies are better.

C.F. Payne

ILLUSTRATORS

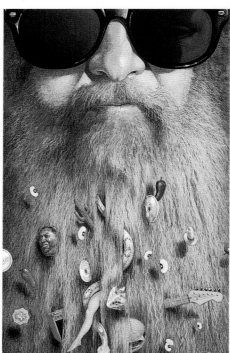

Billy Gibbons
mixed media
11" x 14"

Elton John
mixed media
11" x 14"

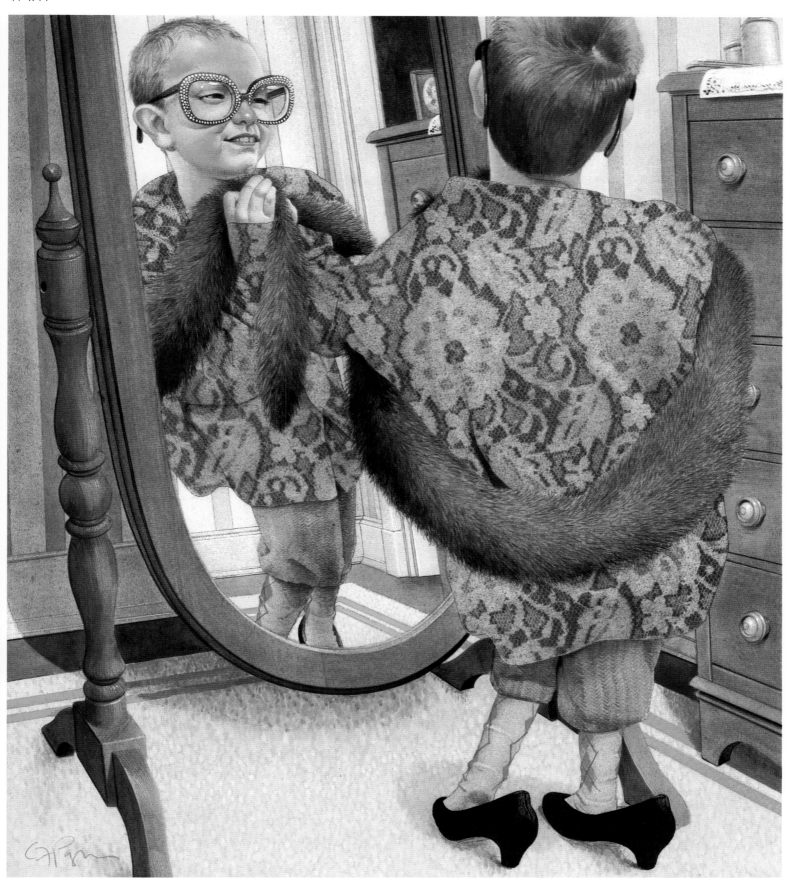

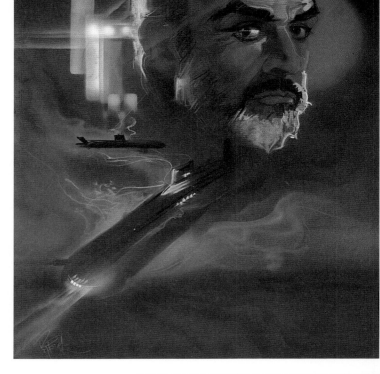

Sean Connery
mixed media
30" x 42"

For me my artwork is an
obsession; my life. I am
continually searching for
beauty and integrating those
visual experiences in my art.
[Bob Peak died in 1992.]

Robert Peak

ILLUSTRATORS

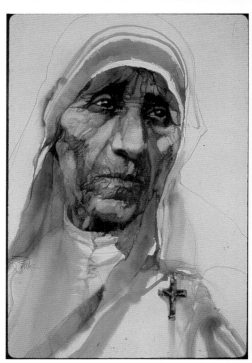

Mother Theresa
watercolor
30" x 41"

Paul McCartney
watercolor
30" x 41"

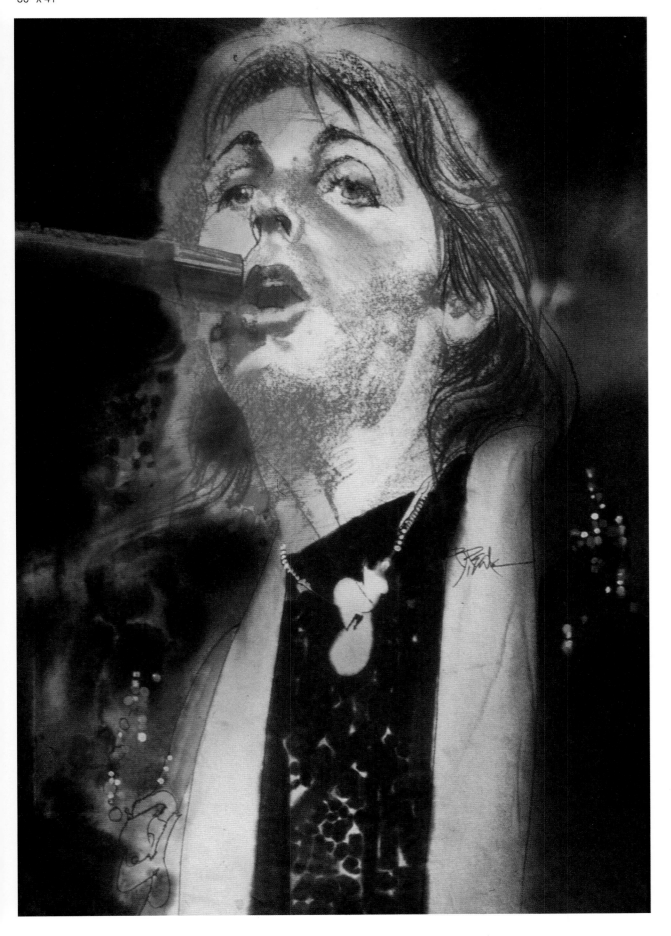

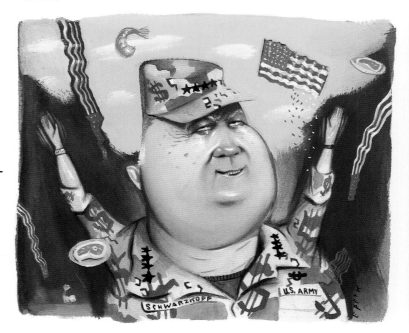

General Schwarzkopf
gouache
10" x 18"

What I try to do with my work
is to make friendly observations
on American culture. I prefer to
develop ideas rather than just
take them in.

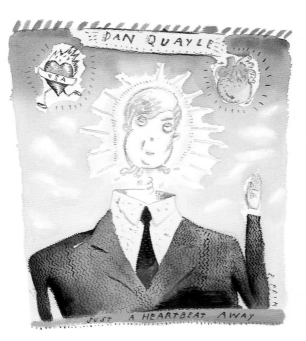

Dan Quayle
gouache
10" x 12"

Everett Peck

ILLUSTRATORS

Andy Warhol
acrylic
10" x 12"

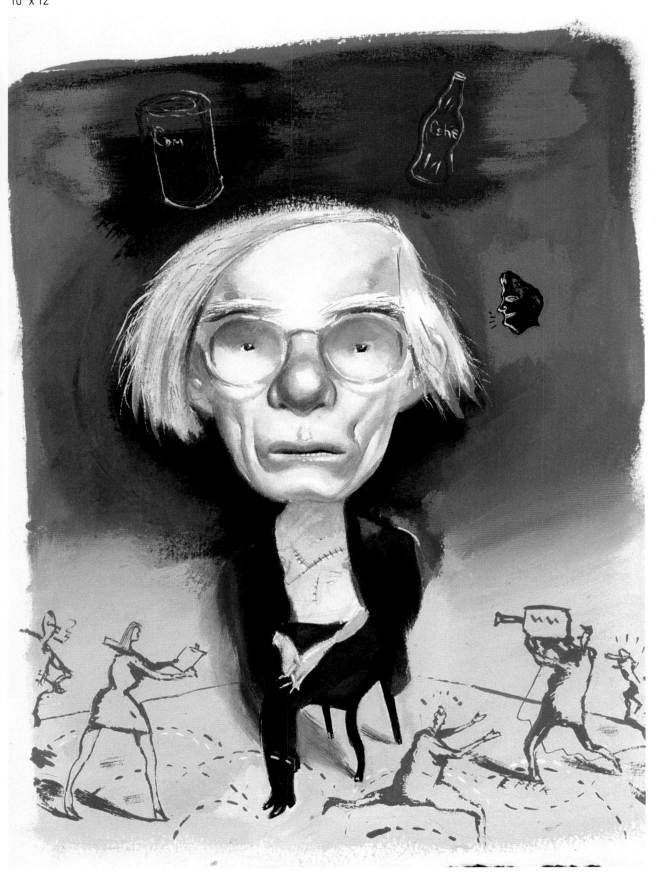

Mikhail Gorbachev
acrylic
13" x 19"

I like to convey a social message with a Renaissance feel. I do some fine art and abstract painting but I find that commercial art is more effective at reaching the masses . . . you can reach three million people much quicker than in the fine art world.

Greg Ragland

ILLUSTRATORS

Marilyn Monroe
acrylic
11" x 14"

Jerry Lee Lewis
acrylic
37" x 20"

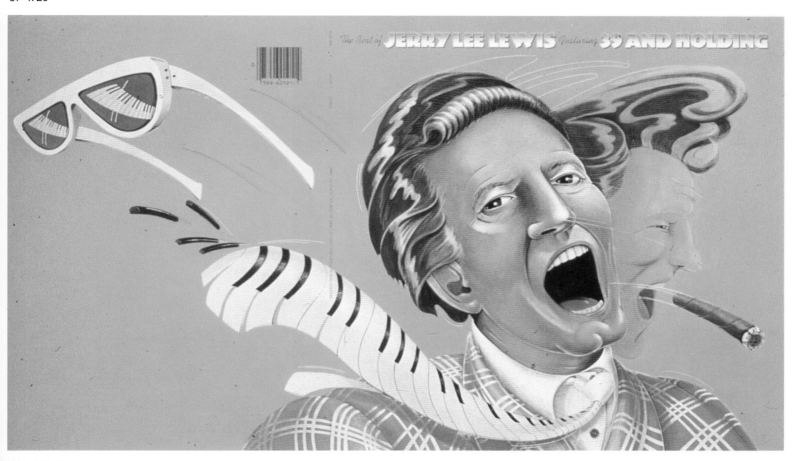

Paul Volcker
acrylic
9" x 12"

Michael Jackson
gouache
15" x 20"

What I try to do is an
impersonation. If it is accurate,
it will expose the subject.
When it all comes together it
should make you smile from
deep within.

Robert Risko

ILLUSTRATORS

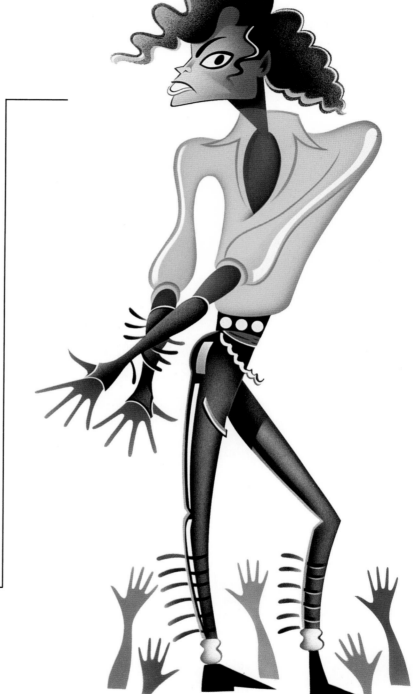

Madonna
gouache
15" x 15"

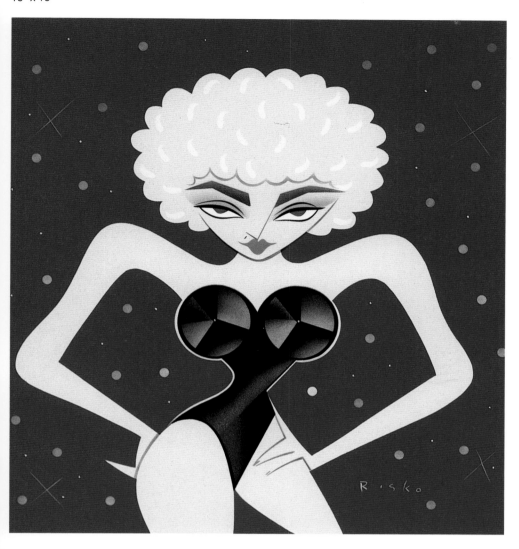

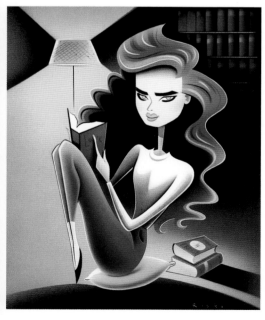

Brooke Shields
gouache
15" x 20"

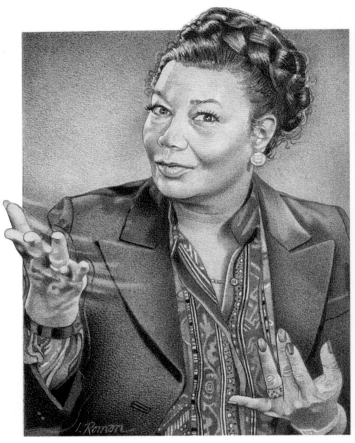

Pearl Bailey
pencil (graphite)
3 ⅝" x 5"

I've always been drawn to
drawing people and especially
love the drama of black &
white portraits. Graphite is my
preferred medium.

Irena Roman

ILLUSTRATORS

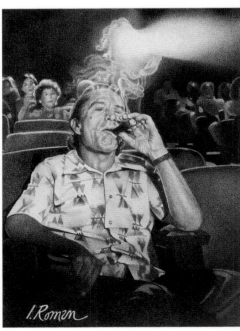

Robert De Niro
pencil (graphite)
4 ½" x 6 ¼"

Danny DeVito
pencil (graphite)
14" x 11"

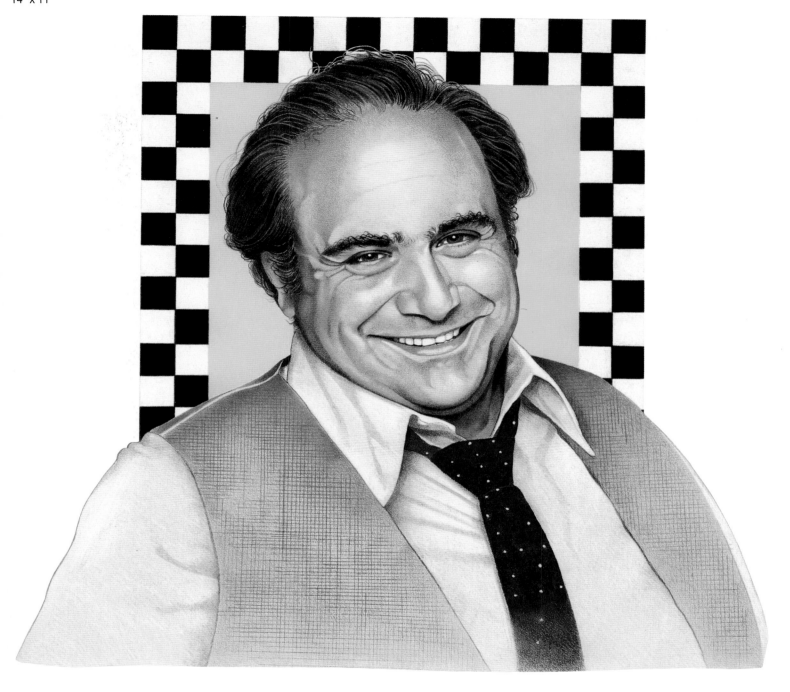

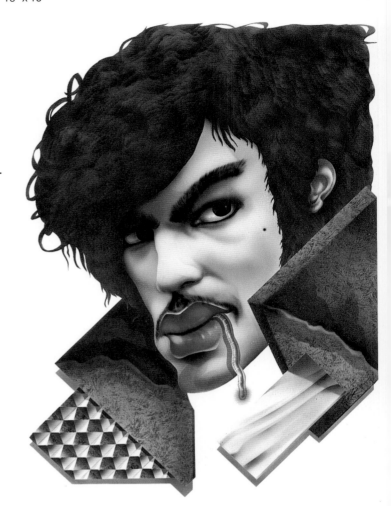

Prince
airbrush
18" x 18"

The creative process is the
essence of my being. I ingest
whatever I see, read, or hear,
then it mutates and is released
in many different forms. . . .
Be Here Now.

Balvis Rubess

ILLUSTRATORS

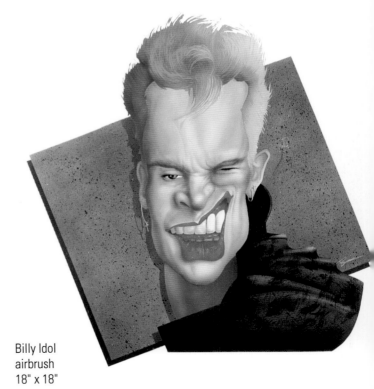

Billy Idol
airbrush
18" x 18"

Salvador Dali
airbrush
15" x 19"

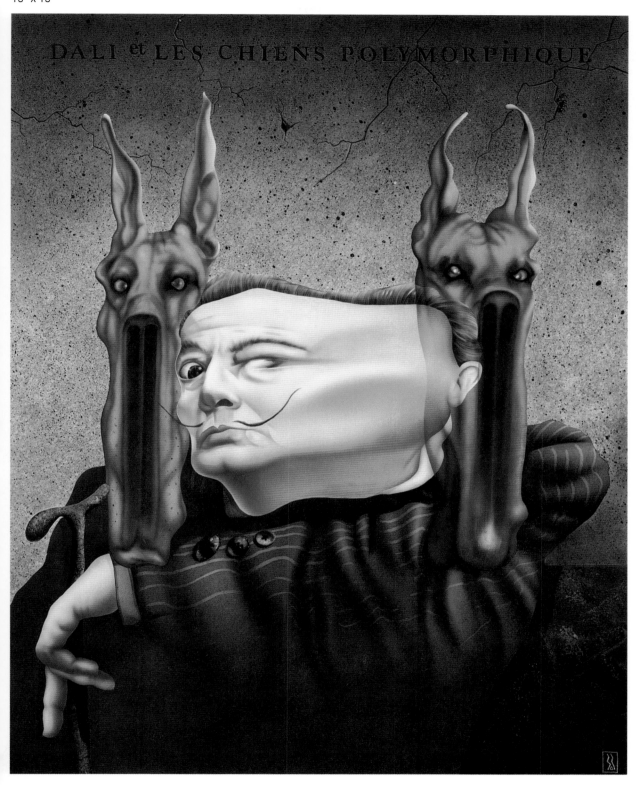

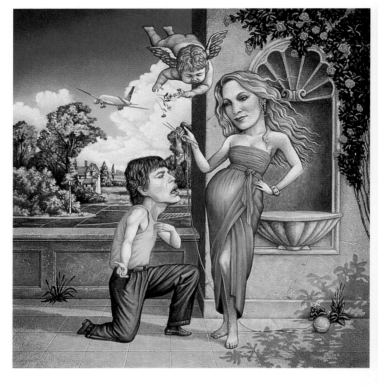

Mick Jagger & Jerry Hall
acrylic & oil
12" x 12"

With a spirit of gentle irreverence I tilt the halos of society's icons as a means of justifying my insipid identity, then fueled by a pint, I scandalize the barmaids, curse the idiot who invented the clock, and with a satirical smile begin the process yet again.

Joseph Salina

ILLUSTRATORS

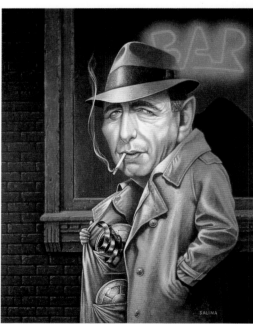

Humphrey Bogart
acrylic
11" x 12"

David Suzuki
acrylic
13 ¼" x 14

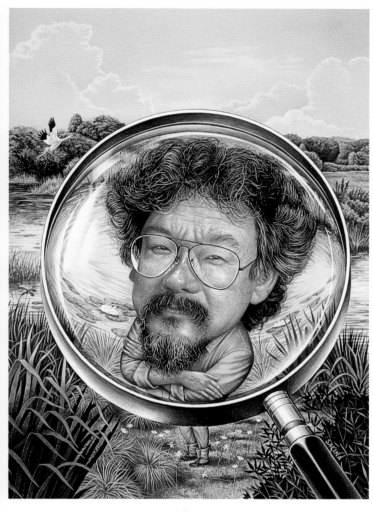

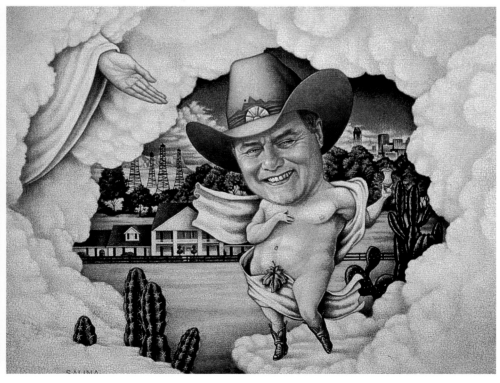

Larry Hagman
resin-acrylic & oil glaze
13" x 10 ½"

.!?

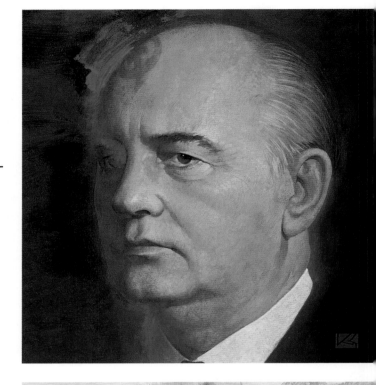

Kazuhiko Sano

ILLUSTRATORS

Keith Richards
acrylic
18" x 24"

William Shatner & Leonard Nimoy
acrylic
15" x 20"

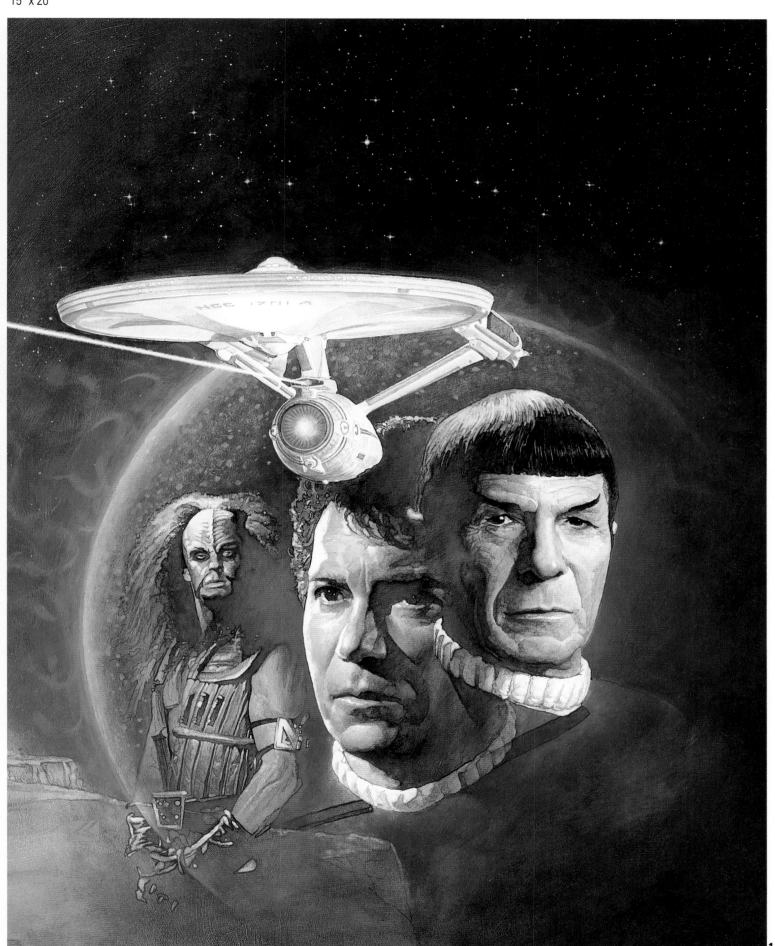

For me, the past continues to be the present. I am entirely without the irony which most painters today put on like a coat when faced with the greatness of the past. I do not paint pastiches. My paintings are not eclectic or mannerist.

Daniel B. Schwartz

ILLUSTRATORS

Winston Churchill
oil
14" x 18"

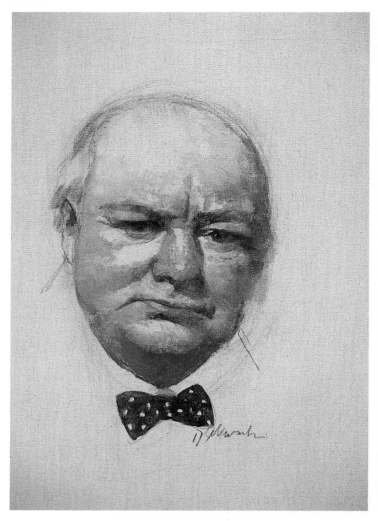

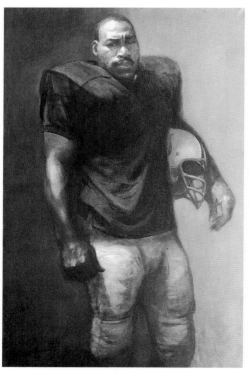

Gene "Big Daddy" Lipscomb
oil
46" x 76"

Gloria Steinem
watercolor
12" x 16"

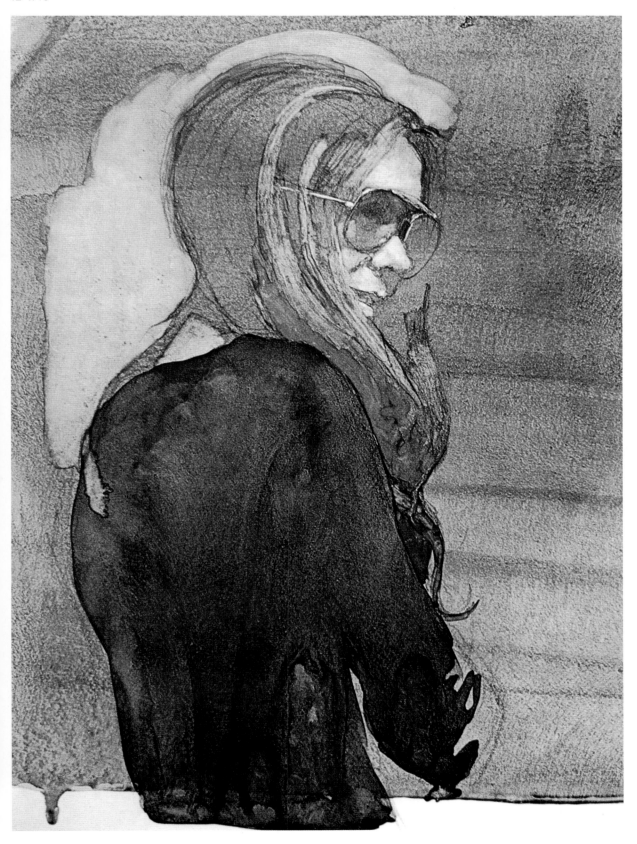

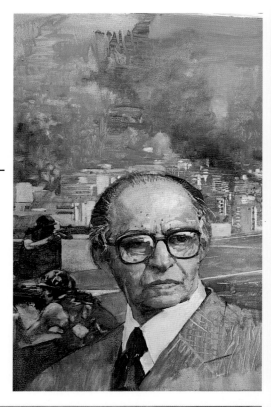

Art has its own language, and it's a language that is different from the words we use. "Wow" is a good initial response from a viewer, because it indicates he or she has stepped onto the pathway by which the artist guides the viewer into his world.

Burt Silverman

ILLUSTRATORS

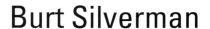

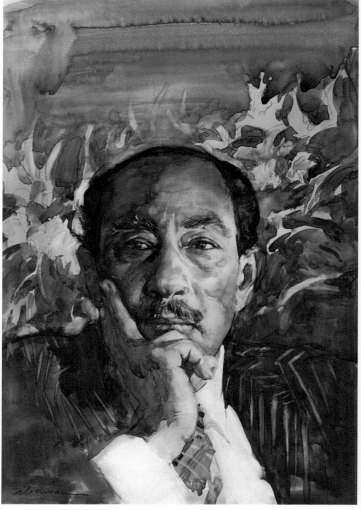

Anwar Sadat
watercolor
15" x 22"

John & Yoko — A Love Story
watercolor on board
22" x 28"

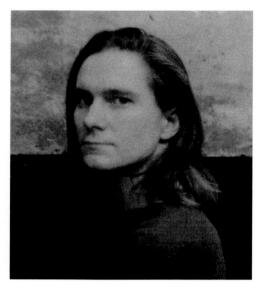

When I am creating a portrait
I attempt to capture the spirit
of the subject and go beyond
the skin.

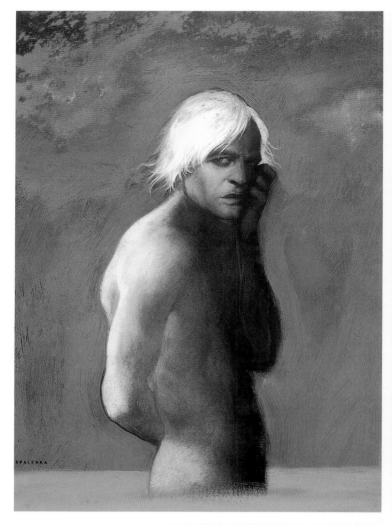

Greg Spalenka

ILLUSTRATORS

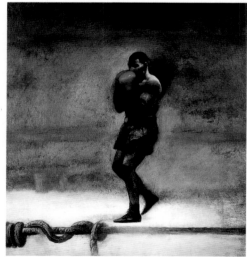

Mike Tyson
oil
20" x 22"

Joe Montana
mixed media
20" x 8"

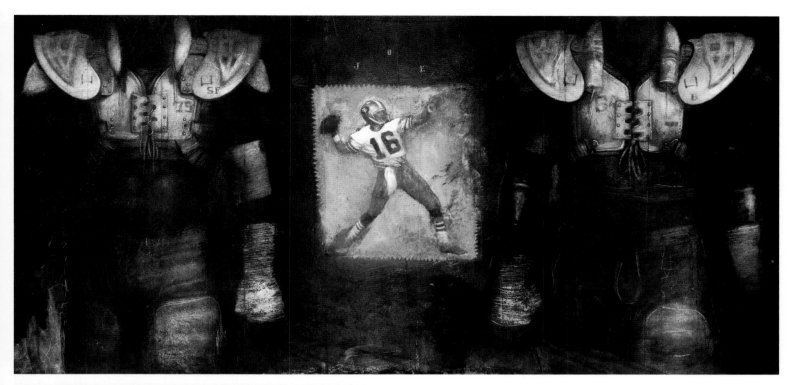

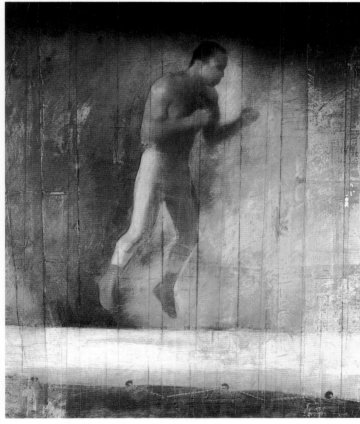

Sugar Ray Leonard
mixed media
9" x 12"

I don't have the intellectual discipline to put myself in the position to cure cancer or end world hunger. Surely almost anything is more valuable to humanity than making pictures; that just makes it more imperative that I try to turn my work to decent ends.

Dugald Stermer

ILLUSTRATORS

Ed Meese
pencil & watercolor
11" x 14"

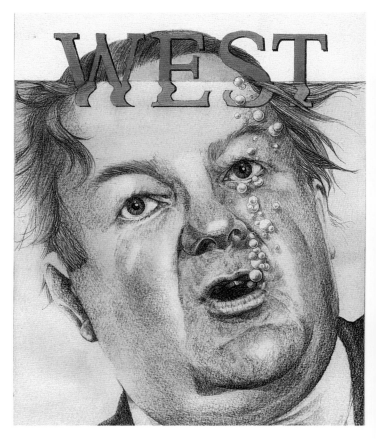

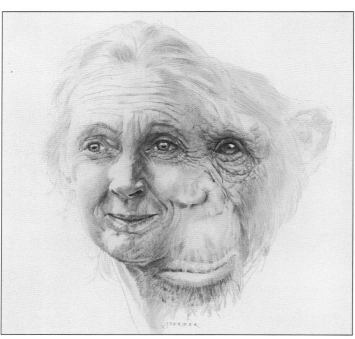

Jane Goodall
pencil & watercolor
14" x 18"

126

Willie Nelson
graphite & colored pencil
12" x 18"

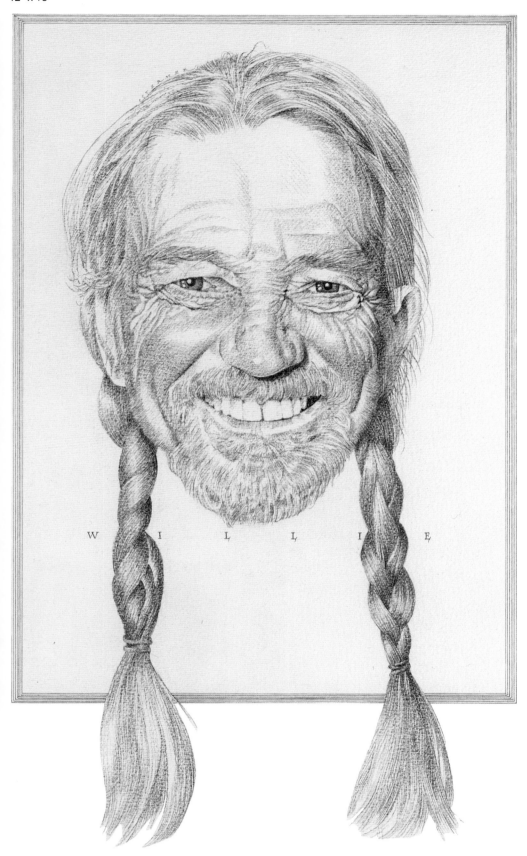

W I L L I E

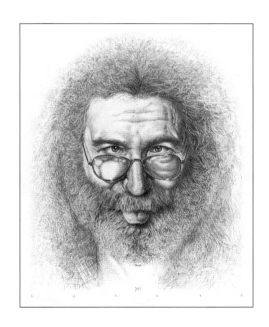

Jerry Garcia
pencil & watercolor
18" x 24"

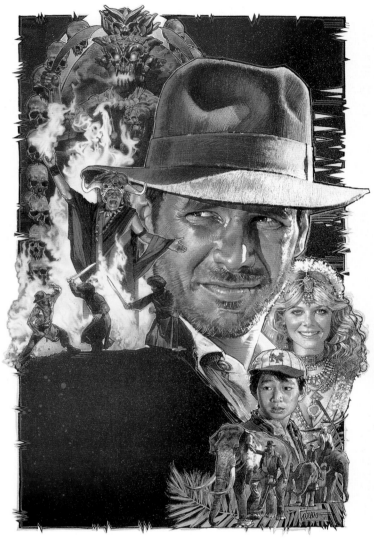

Indiana Jones
mixed media
25" x 34"

If I had something to say, I'd write a book. Here's what others have said about my work:

"My favorite movie artist"
Steven Spielberg, Movie Director
"I'm your greatest fan!"
Michael J. Fox, Actor
"The greatest poster illustrator"
The Boston Globe
"I truly appreciate your talent as an artist."
George Lucas, Movie Director

Drew Struzan

ILLUSTRATORS

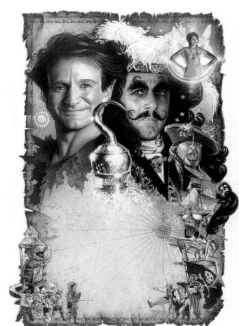

Hook
mixed media
25" x 34"

Mr. Spock
mixed media
25" x 34"

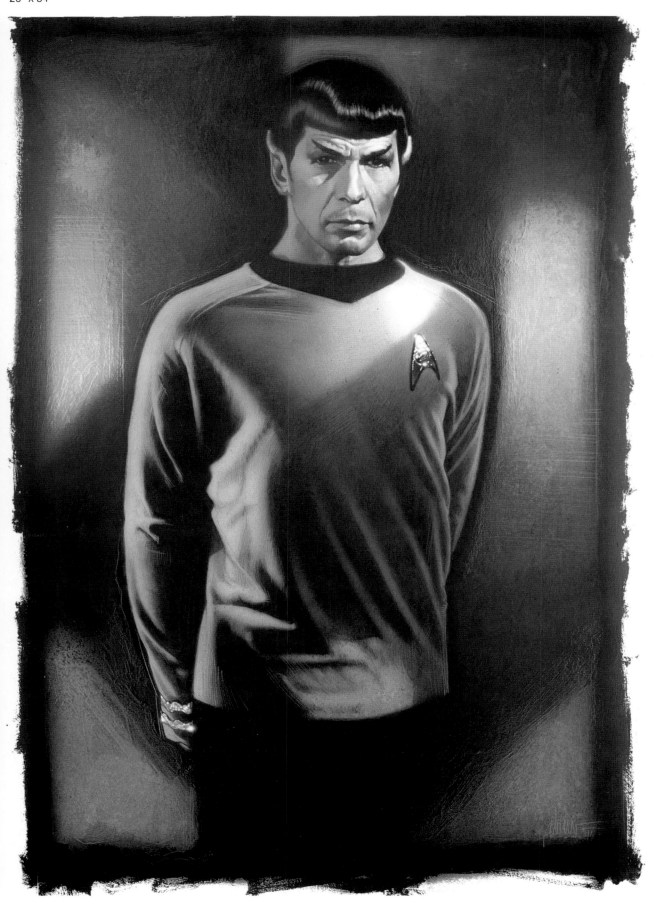

I try to always remember that a celebrity is also a real person — it's the real person that I enjoy painting.

John Thompson

ILLUSTRATORS

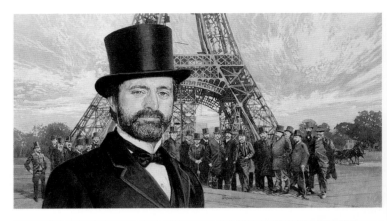

Gustave Eiffel
acrylic
27" x 16"

Mayor Edward Koch
acrylic
17" x 22"

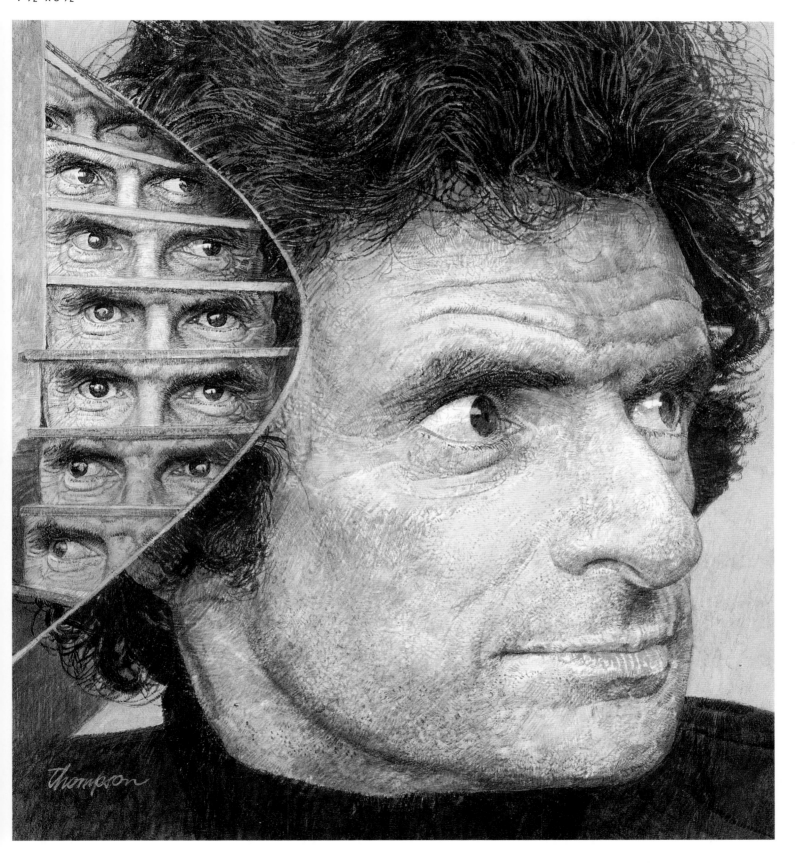

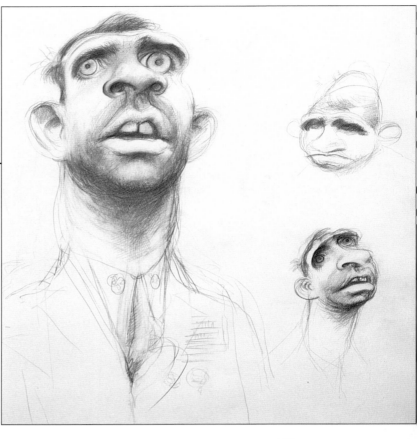

Oliver North
pencil
10" x 12"

I believe that at its best caricature is predatory and spontaneous. The first stroke should pin the subject on its point and hold him on the page for quick rendering. What could be more fun than reducing a dour icon like Beethoven to a big scowl with a bad haircut?

Richard Thompson

ILLUSTRATORS

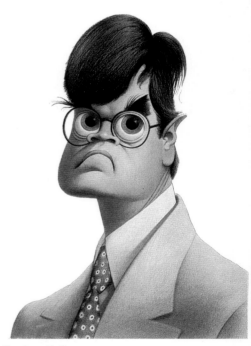

Garrison Keillor
colored pencil
10" x 13"

Beethoven
colored pencil & pastel
8" x 9"

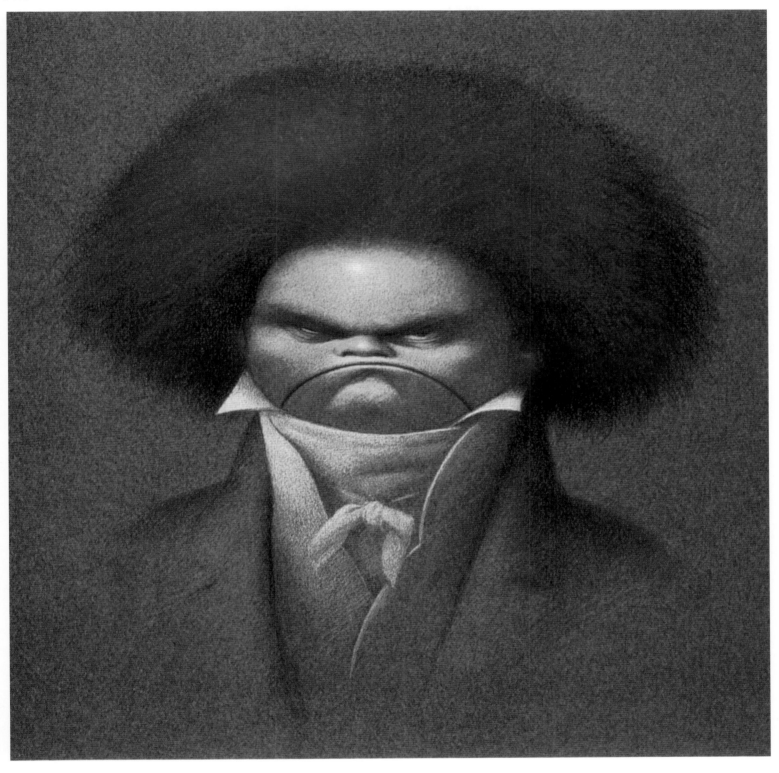

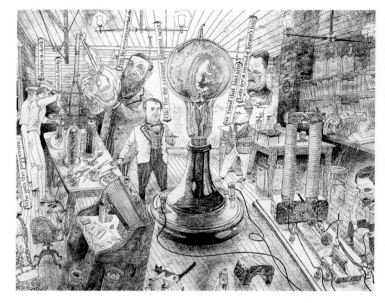

Thomas Edison
ink & watercolor
15" x 20"

In a purely imaginative work,
the idea is the single most
important part. The final piece
is just an enhanced, polished
version of that original mental
impression. The figures in my
work may be called imagina-
tive, but they're all based on
some kind of realism, and I use
tools including scale, light, line
and spattering to create them.

Jack Unruh

ILLUSTRATORS

Henry Ford
ink & watercolor
15" x 20"

Muddy Waters
ink & watercolor
15" x 20"

Gregg Allman
acrylic & airbrush
16" x 20"

Debt

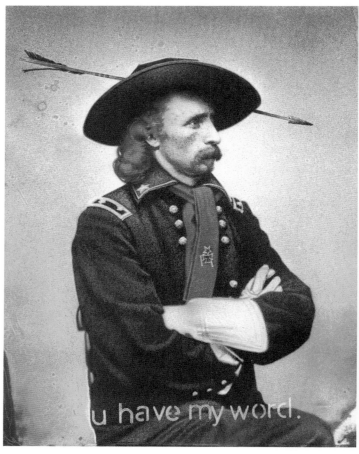

u have my word.

Custer
acrylic & oil
16" x 20"

Stan Watts

ILLUSTRATORS

Freddy Krueger
acrylic & airbrush
20" x 16"

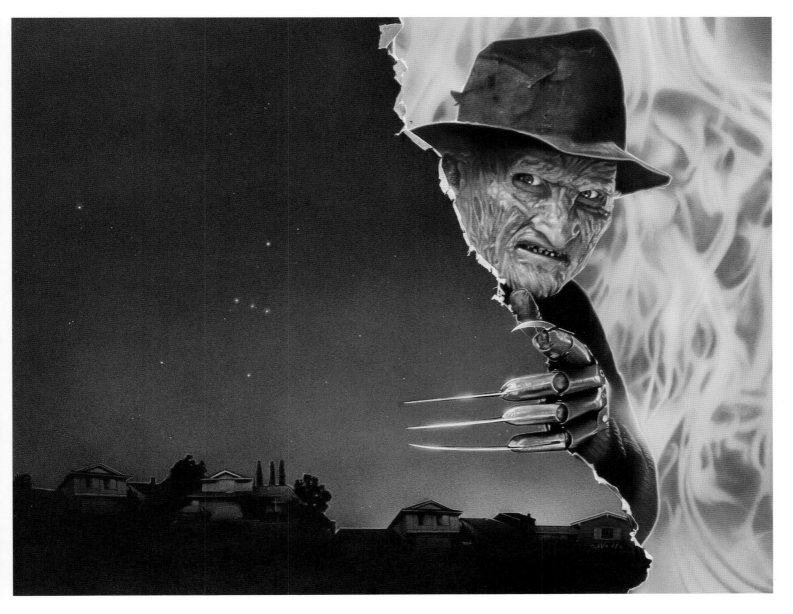

When I was very young, I accompanied my father on a visit to a friend of his. They talked and did other boring adult things. To stop me fidgeting, my father's friend eventually found me a How to Draw book, some paper, and a pencil. This is my first memory of drawing, and it has kept me from fidgeting ever since.

Don Weller

ILLUSTRATORS

Paul Volcker
watercolor
20" x 30"

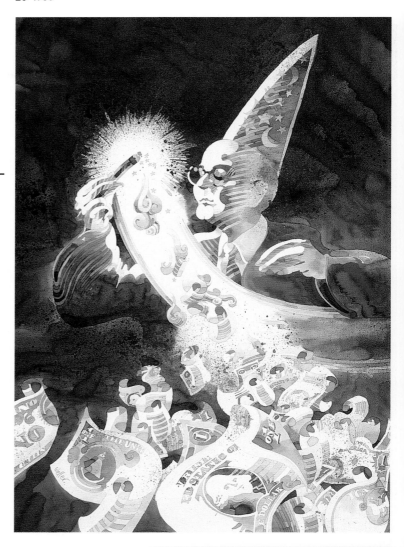

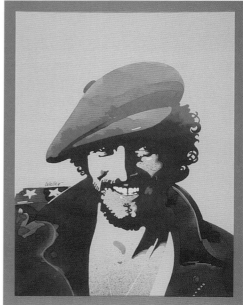

Bruce Springsteen
watercolor
15" x 20"

William Shakespeare
watercolor & colored pencil
18" x 24"

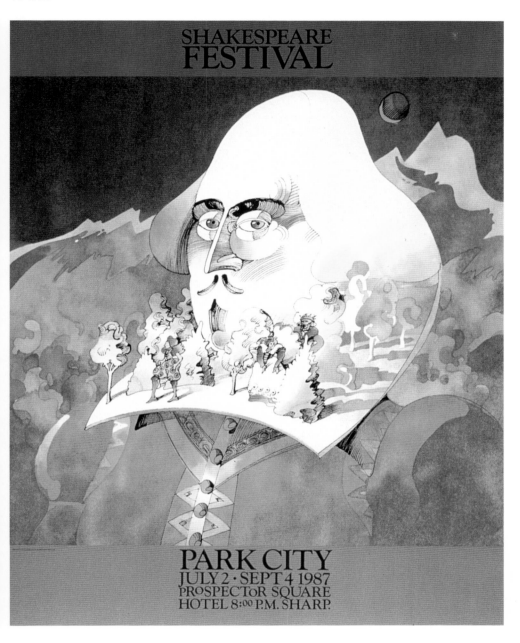

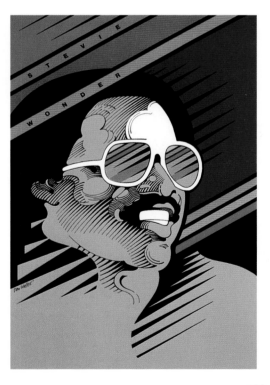

Stevie Wonder
ink, pantone color sheets
15" x 20"

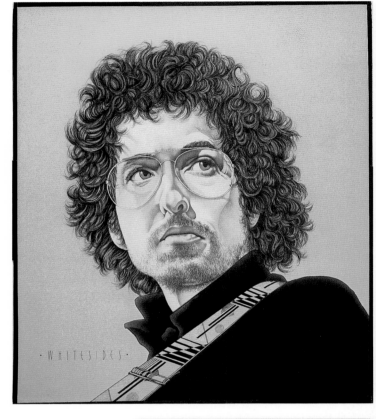

For me painting isn't a question of common sense or anything rational: painting is an organic flow from my higher self that meets the needs at hand.

Kim Whitesides

ILLUSTRATORS

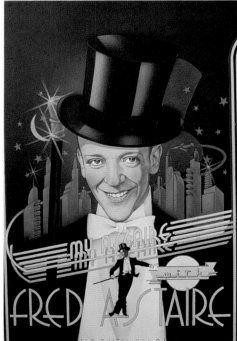

Fred Astaire
graphite & watercolor
12" x 18"

Elvis
acrylic
20" x 30"

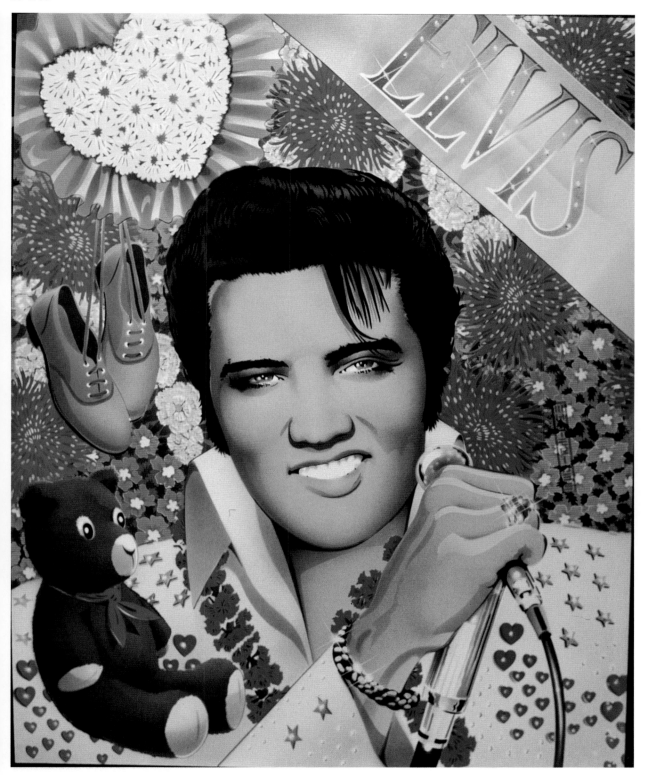

Star Bores (from lower left: Madonna, Sen. Edward Kennedy, Roseanne Barr, Joan Collins, Sting, Nancy Reagan, Cher, Liz Taylor, Michael Jackson, Bo Jackson [center])
watercolor, pen & ink
24" x 18 "

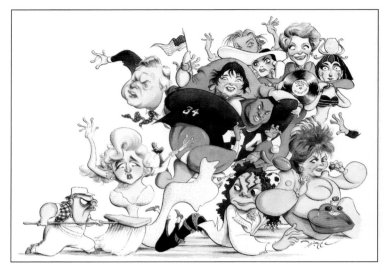

Star Bores (from lower left: Madonna, Sen. Edward Kennedy, Roseanne Barr, Joan Collins, Sting, Nancy Reagan, Cher, Liz Taylor, Michael Jackson, Bo Jackson [center])
watercolor, pen & ink
24" x 18 "

There are few experiences in life more agonizing than facing a looming deadline and attempting to achieve, in one's 743rd consecutive sketch, the definitive likeness of say, Humphrey Bogart. Nonetheless, there are few experiences more satisfying than seeing Humphrey magically appear, (when before only a stranger stared back at you) after simply thickening the stranger's eyebrows.

Michael C. Witte

ILLUSTRATORS

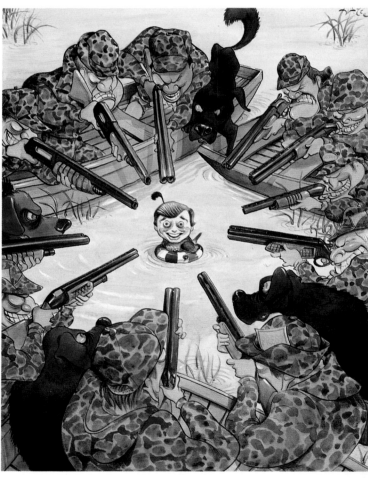

Dan Quayle
watercolor, pen & ink
18" x 24"

Madonna
watercolor, pen & ink
12" x 12"

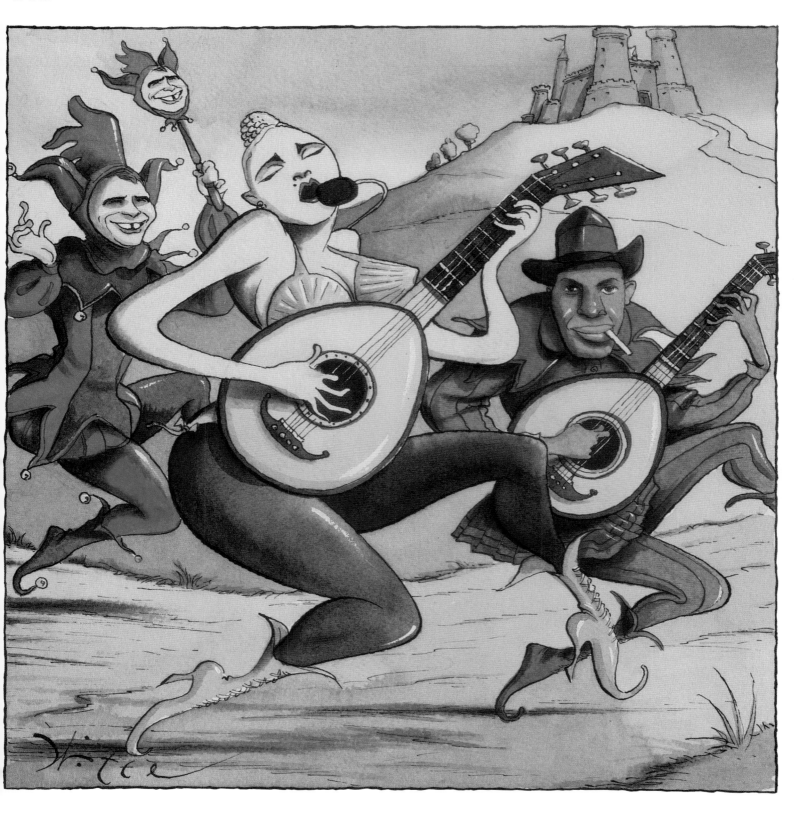

GALLERY

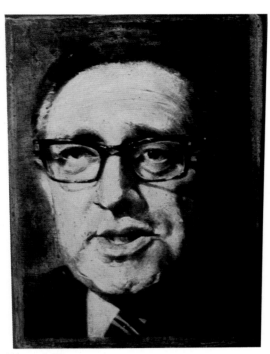

Edward Abrams
Henry Kissinger
acrylic on board
8" x 11"

Gallery

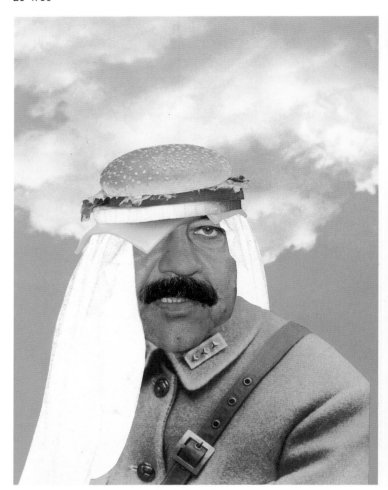

Lou Beach
Saddam — "Meat Head of the Desert"
collage
20" x 30"

Diane Best
Man Ray
mixed media
16" x 22"

Bill Brown
Bobby McFerrin
ink & dyes
15" x 20"

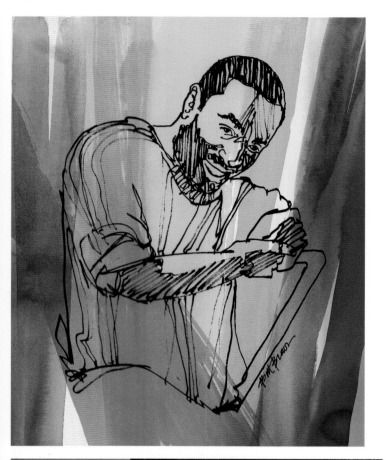

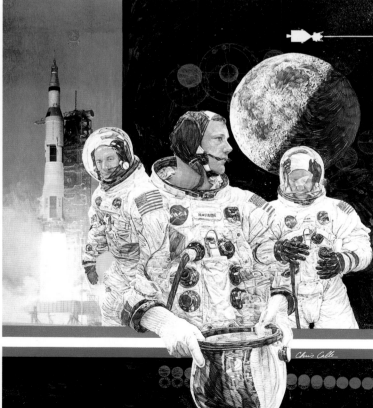

Steven Chorney
Sitting Bull
acrylic
8" x 14"

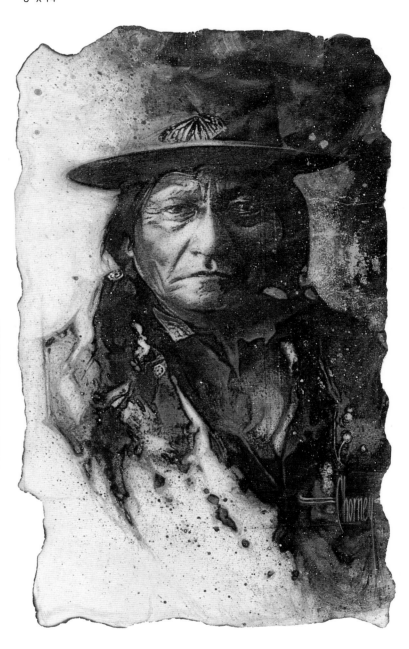

Chris Calle
Apollo II Astronauts — Armstrong, Collins, Aldrin
mixed media
12" x 14"

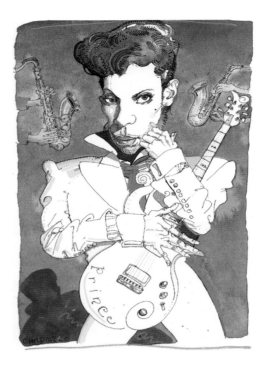

Joseph Ciardiello
Prince
pen & ink, watercolor
10" x 14"

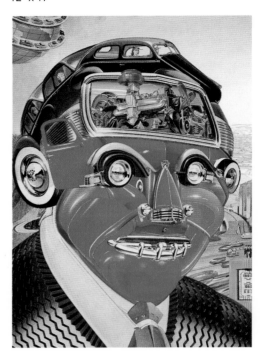

John Craig
Henry Ford
collage
12" x 17"

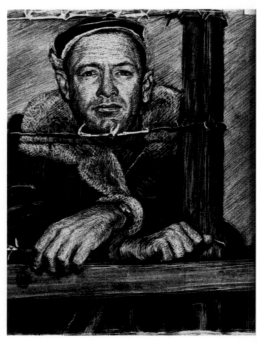

Alicia Czechowski
William Holden
scratchboard
3 ½" x 3 ½"

Gallery

Georganne Deen
William S. Burroughs
gouache & collage
13" x 17"

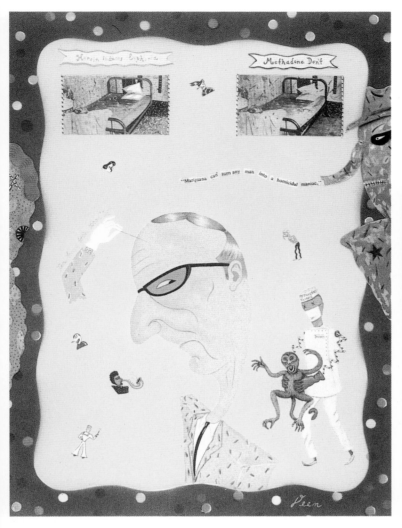

C. Michael Dudash
Mickey Rooney
oil on gessoed masonite
16" x 22"

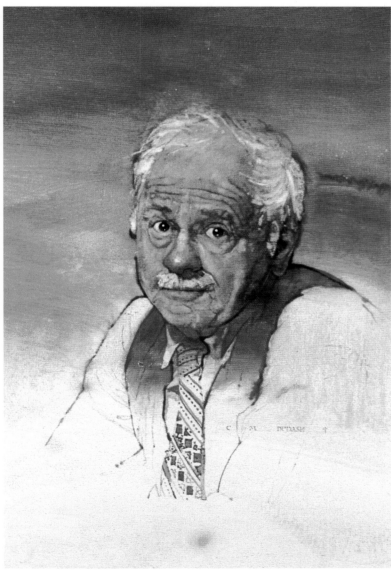

Rod Dyer
"Here's Johnny"
photography & paint
11" x 14"

Linda Fennimore
Carly Simon
oil
60" x 60"

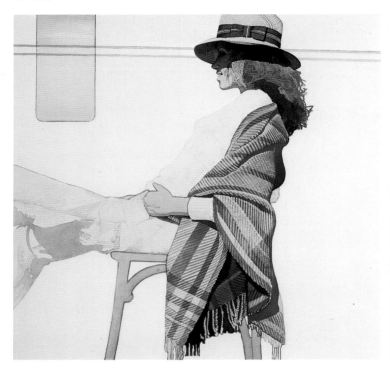

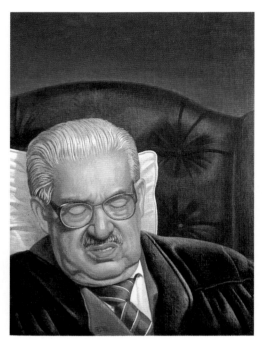

Teresa Fasolino
Thurgood Marshall
acrylic
12" x 12"

Gallery

Mark Frederickson
Madalyn Murray O'Hair
acrylic
12" x 15"

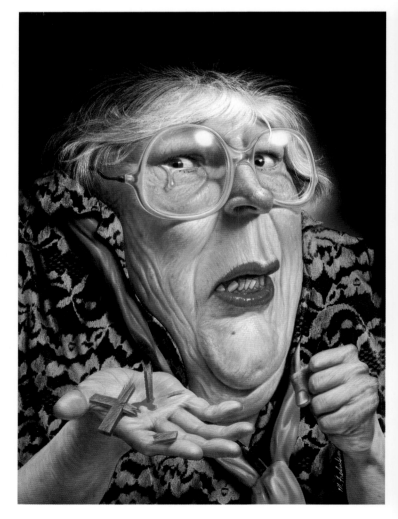

Robert Giusti
Faye Dunaway & Bela Lugosi
acrylic on canvas
14" x 14"

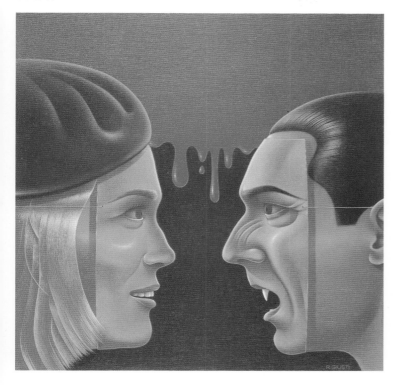

Josh Gosfield
Edith Piaf's Letter to Elvis
acrylic
24" x 30"

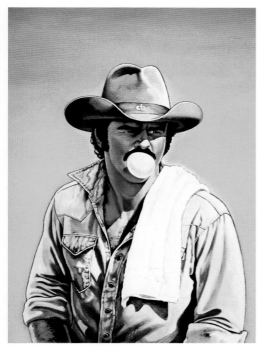

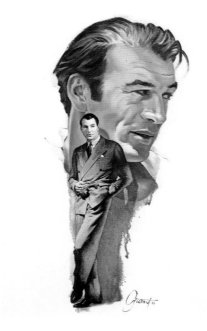

Joe Garnett
Burt Reynolds
oil
24" x 30"

Stan Grant
Gary Cooper
oil
20" x 30"

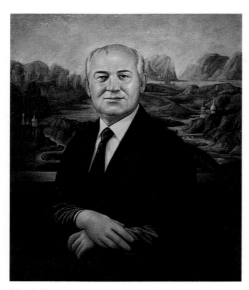

Mark Hess
Mikhail Gorbachev — "Mona Gorbachev"
oil
14" x 18"

Gallery

Fred Hilliard
Santa Claus
pen & ink with watercolor
16" x 22"

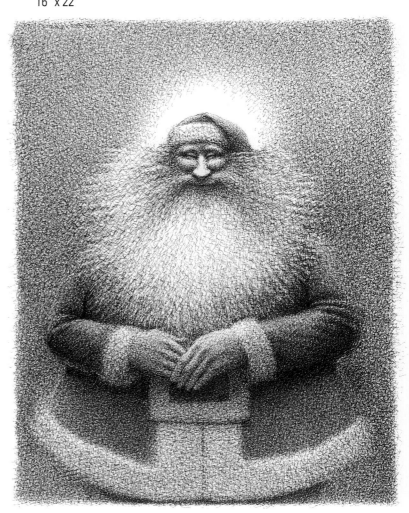

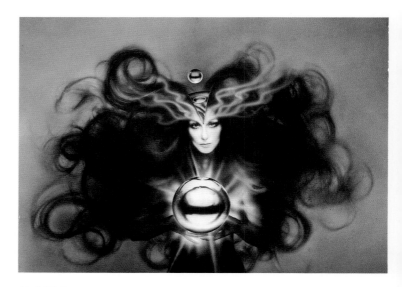

Bob Hickson
Cher
acrylic on photo
20" x 15"

Dave Hudson
Tip O'Neill
acrylic
10" x 15"

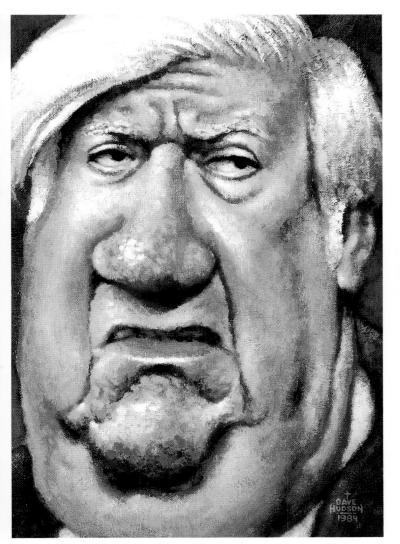

Curt Hrabe
Mr. T — "The Suburban Woodland Controversy"
pencil on gesso/watercolor dyes
9" x 12"

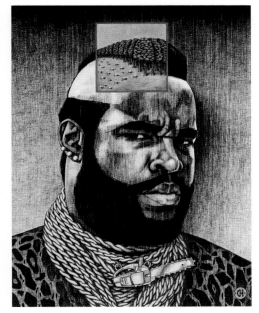

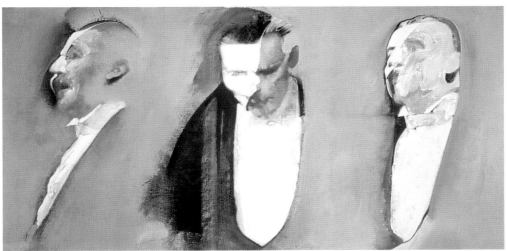

Robert Heindel
Michael Crawford (as Phantom of the Opera)
oil on canvas
36" x 18"

Robert Hunt
Peter Lorre
oil
12" x 18"

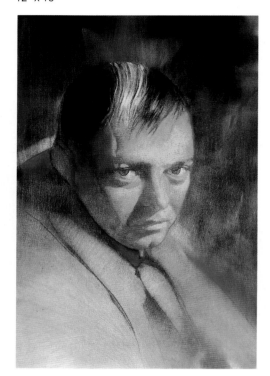

John Jinks
Marilyn Monroe — "Marilyn in the Mirror"
acrylic
25" x 34"

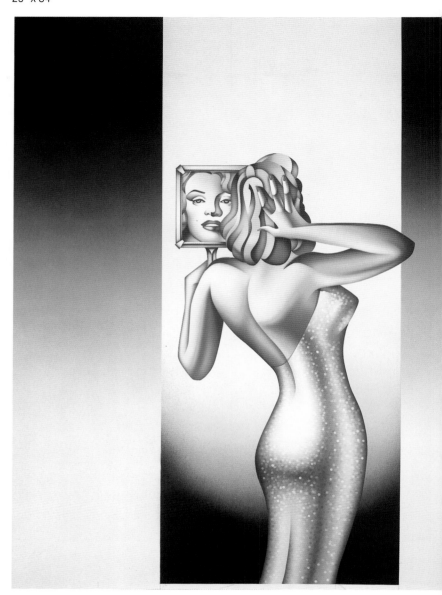

Gallery ⎯⎯⎯⎯⎯⎯⎯⎯

Stephen Kroninger
Woody Allen
collage
8" x 10"

Joel Peter Johnson
Elvis (in Heaven)
oil on board
22" x 14 ½"

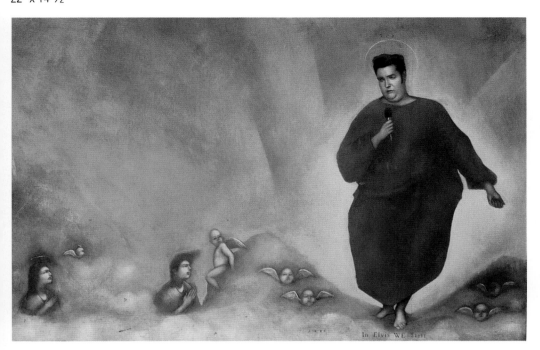

David Lesh
Mother Theresa
mixed media
8" x 10"

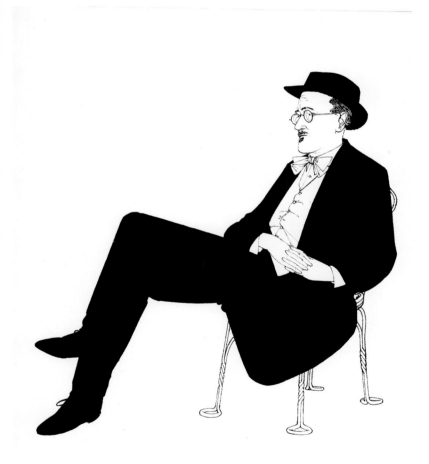

Tim Lewis
Bob Hope
watercolor
7 ⅛" x 10"

David Johnson
James Joyce
pen & ink
18" x 24"

Overton Loyd
Alex Haley
airbrush & watercolor
12" x 15"

Gallery

Steve Miller
Janis Joplin
ink & gouache
13" x 13"

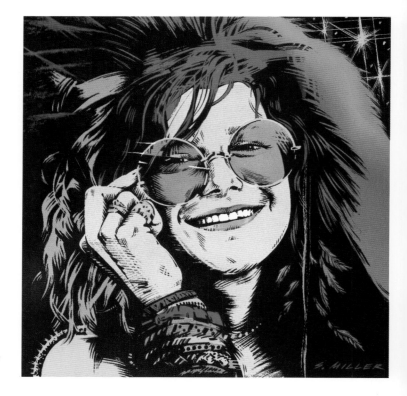

Bill Murphy
Mickey Rourke
colored pencil
10" x 12"

Rich Mahon
William Hurt
acrylic
30" x 40"

Ron Netsky
Mu'ammar Qaddafi
monotype
18" x 22"

Chris Notarile
Ann-Margret (from a photograph by Mario Casilli)
colored pencil on vellum
11 ¾" x 15 ¾"

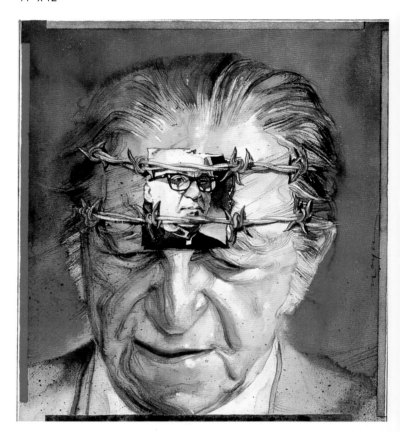

Gallery

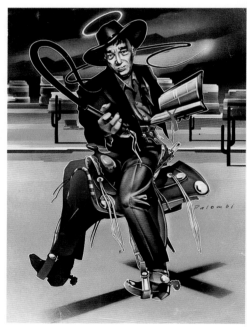

Peter Palombi
Lash La Rue
Dr. Martin dyes over line
18" x 24"

Tim O'Brien
Boris Yeltsin
oil
20" x 26"

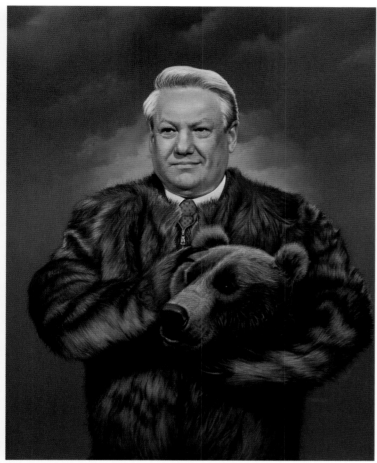

Dick Palulian
Martin Luther King, Jr.
gouache & pastel
13 ½" x 17 ½"

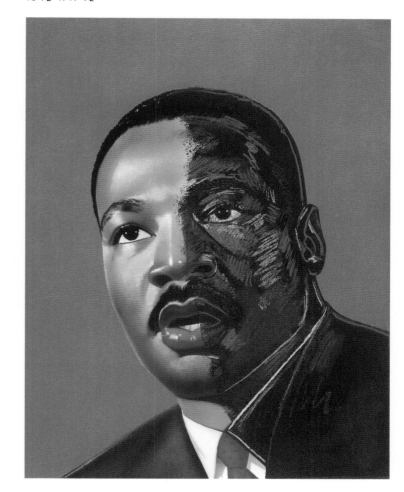

Daniel Pelavin
Alexander Graham Bell
opaque watercolor
12" x 18"

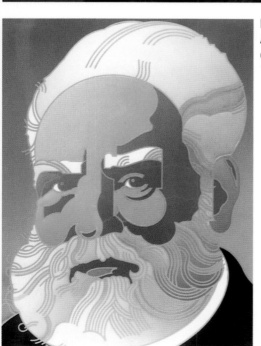

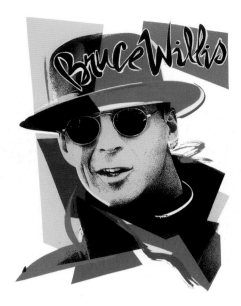

William Rieser
Bruce Willis
mixed media
16" x 20"

Gallery

Robh Ruppel
Orson Welles
acrylic
20" x 15"

Laurie Rosenwald
Bill Cosby
ink
12" x 14"

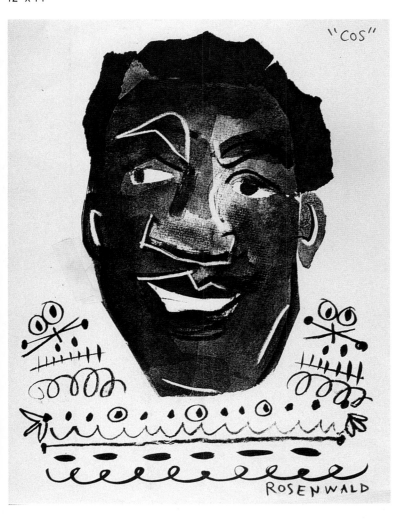

Ward Schumaker
Lotte Lenya, 1928
pencil
16" x 22"

David Stevenson
Frank Lloyd Wright
ink on vellum/blueprint
9 ½" x 14"

Phil Roberts
Jeff Goldblum
pen & ink and watercolor
20" x 30"

Gallery

Bill Sienkiewicz
Charlie Chaplin
tempera on canvas
17" x 26"

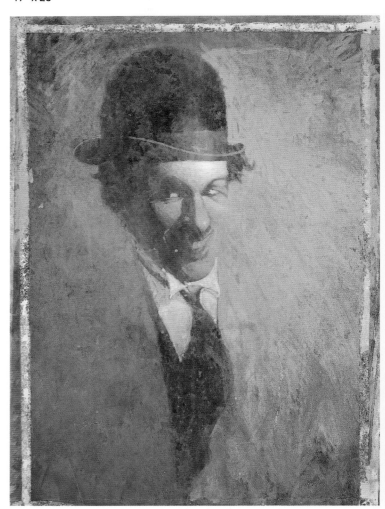

David Suter
Fidel Castro
pen & ink
10" x 8"

William Stout
Who's Zoo (clockwise from upper left: Pete Townsend, Roger Daltrey, Keith Moon, John Entwhistle)
watercolor, prismacolor, & paper collage
18" x 18"

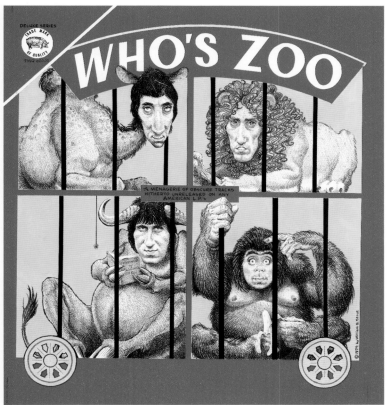

Mark Summers
Lyndon B. Johnson
scratchboard
6" x 7"

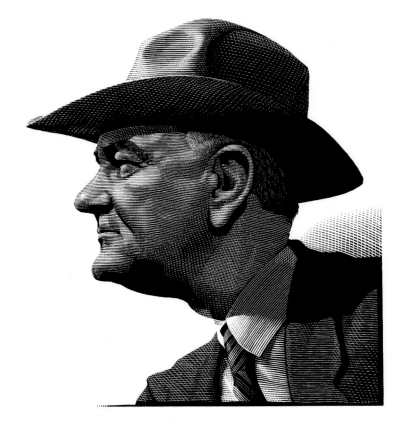

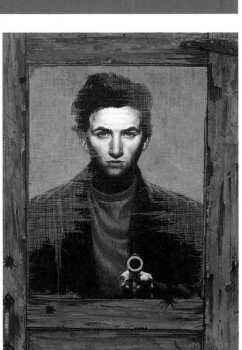

Robert Tanenbaum
Sean Penn
casein
24" x 30"

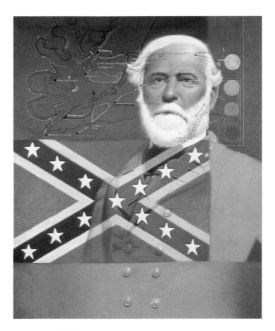

Brent Watkinson
Robert E. Lee
oil on illustration board
20" x 30"

Gallery

Dahl Taylor
Benny Goodman & Friends: Lionel Hampton, Teddy Wilson, Gene Krupa
acrylic on linen
28" x 28"

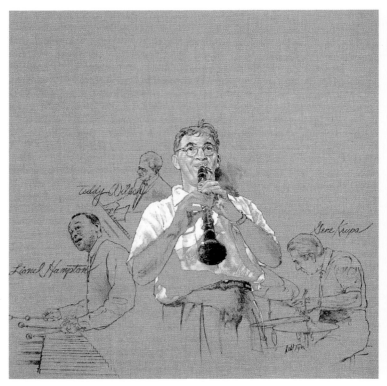

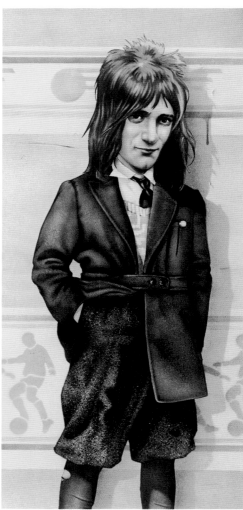

Charles White
Rod Stewart
Dr. Martin's dye & airbrush
4" x 5"

Sam Viviano
Abe Lincoln
ink & dyes
8" x 18"

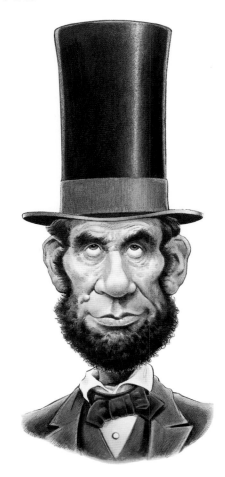

Janet Woolley
Eric Clapton
acrylic paint over photo collage
9 ½" x 14 ¼"

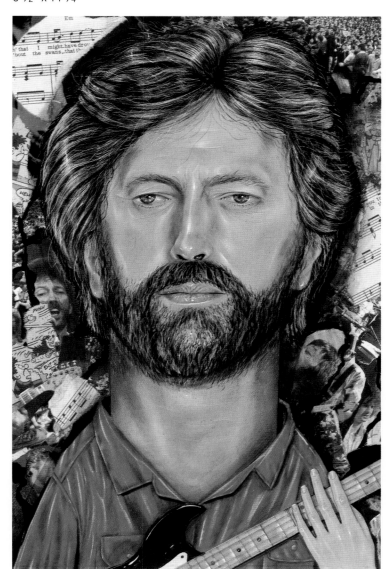

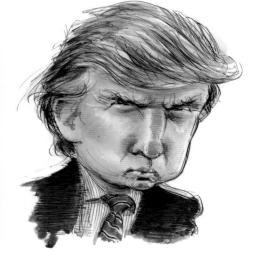

Ed Wexler
Donald Trump
pen & ink and watercolor
10" x 12"

Dave Woodman
Johnny Carson
acrylic
20" x 16"

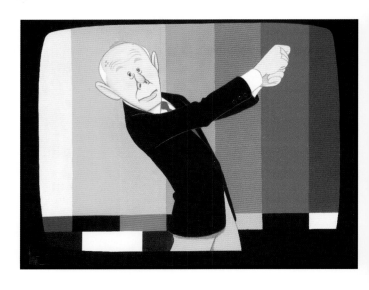

James Yang
George Bush "Lips"
mixed media
8" x 12"

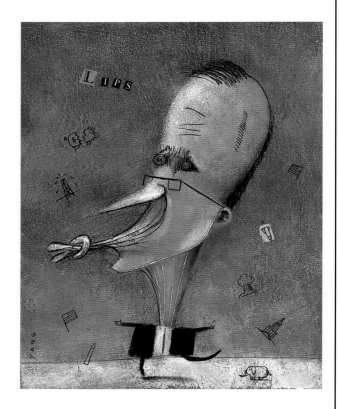

Ren Wicks
Sun Yat Moon and the "Moonies"
mixed media
20" x 30"

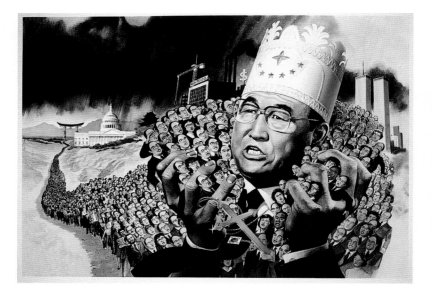

Gallery

BIOGRAPHIES

Edward **Abrams**, at age nine, asked his mother if he could go live with Matisse. He trained in painting at the Cleveland Institute of Art. His work can be seen in galleries, magazines, and on movie posters, and he is the recipient of the Judges Award from the Society or Illustrators. Contact: (619) 765-2615

Brian **Ajhar** was graduated from the Parsons School of Design in 1980. His humor, whimsy, and painting technique have garnered many awards and a client list that features the top american business, consumer, and graphic arts publications. Rep: Pamela Korn (717) 595-9298

Julian **Allen** has won numerous awards from the Society of Illustrators, *American Illustration,* and others. His monthly comic strip "Wild Palms" is in *Details* magazine, and his work can be seen in Society of Illustrators' annuals, the book *The Art of New York* (Abrams, 1983), and in *Innovators of American Illustration* (Van Nostrand Reinhold, 1986). Contact: (212) 925-6550

Kent H. **Barton** is the art director of *Sunshine Magazine* of the Fort Lauderdale *Sun-Sentinel* newspaper. His illustrations have appeared in every *Graphis* annual since 1979 and the Society of Newspaper Designers honored him with silver awards for illustration in 1982 and 1984. News America Syndicate nationally syndicated his "Viewpoint" illustrations from 1981 to 1985. Contact: (706) 379-2041

Lou **Beach**, the "Clown Prince of Collage" is best known for his album cover work and his illustrations. He is much sought after for his quick wit and conceptual abilities. While most of his recent work is computer based, he is still known to rip some paper and throw some glue while finding time to teach editorial Illustration at Otis/Parsons School of Design. Contact: (213) 934-7335

Pearl **Beach**'s parents were both illustrators. After winning a scholarship to Chouinard School of Art, she created posters and costumes for the Oingo Boingos. Her fine art and art glass works have been shown in galleries in Los Angeles, Pasadena and New Mexico, and she has won awards from the Society of Illustrators and the Art Directors Club of Los Angeles. Contact: (213) 256-2170

Diane **Best** was born in Boston and was graduated from the San Francisco Art Institute. She now lives in Los Angeles where she paints commissioned portraits, exhibits in local galleries, and does commercial work for the entertainment industry. Contact: (909) 585-5785

Thomas **Blackshear** is known for his dramatic lighting and sensitivity to mood. Twenty-eight of his stamp designs for the U.S. Postal Service's Black Heritage series can be seen in the commemorative book *I Have a Dream* (1992) and nineteen of his paintings are exhibited at the Smithsonian Institution in Washington. Contact: (719) 636-5009

Tom **Bloom** was very young when he was born. He won a few awards and gained notoriety as a quick wit with a fine line (siblings point out that it was indeed a fine line and that he was in fact a nit wit). He doesn't have a large client list but they are steady and they let him be funny. As a result, sometimes they've groaned. Contact: (914) 761-1877

Christoph **Blumrich** was born in Germany and worked as a graphic designer in Vienna before moving to New York in 1960, where he designed exhibits for NASA. Evening courses at the School of Visual Arts led to work as a magazine art director and free-lance illustrator. He prefers assignments that challenge his intellect as well as his artistic ability. Contact: (516) 757-0524

Tim **Bower** received his BFA from the Academy of Art College in San Francisco. He presently works in New York City where his time is filled with illustration deadlines, unfinished oil paintings, finding available tennis courts, and completing his masters degree. Contact: (415) 821-2046

Charles **Bragg**'s poignant and serious statements, cloaked in bold irreverent humor, lie at the core of his art. He is an etcher, painter, and lover of laughs. Nothing is sacred in the world according to Bragg. His work hangs in museums around the world, and a complete list of his awards, one-man and selected exhibitions, and commissions would easily fill this entire page. Contact: (310) 274-9453

Braldt **Bralds** is a self-taught illustrator, who moved to New York City from his na-

tive Holland in 1980. His first assignment was a cover for *Time* magazine and since then he has landed top illustration jobs with *Newsweek*, *Playboy*, *TV Guide*, Chevron, and Budweiser. He has won over a dozen gold and silver medals, including four from the Society of Illustrators. Contact: (203) 868-7577

Steve **Brodner** is Brooklyn born. In 1972 he began drawing political cartoons for his high school paper and since 1980 has covered every national political convention. His many awards include silver medals from the Society of Illustrators Humor Shows of 1988 and 1990. Contact: (212) 740-8174

Bill **Brown** is a graphic designer and illustrator who is currently the creative director for Fattal & Collins in Santa Monica. His work has been published in *Art Direction*, *Print*, and the Los Angeles Art Director's Club annuals (1977, 1978). He has taught at Art Center, Otis/Parsons School of Art and Design, and is now an associate professor in the newly created design department at UCLA. Contact: (310) 822-5869

David Edward **Byrd**'s posters are represented in many museums around the world. His *Tommy*, *Godspell*, *Little Shop of Horrors*, *Steel Magnolias*, Rolling Stones 1969 Tour, and Woodstock Festival posters have become collectors' items. He received his MFA from Carnegie Mellon University and is presently a senior illustrator at Warner Brothers Studios Creative Services. Contact: (213) 469-2890

Chris **Calle** has completed projects for many major advertising and editorial clients including NASA and *Reader's Digest*. He has designed over twenty postage stamps for the U.S. Postal Service including those of Harry S. Truman and the 20th Anniversary of the First Man on the Moon. Contact: (203) 438-5226

Steven **Chorney** specializes in illustrating for the entertainment industry and has produced the key art for many motion-picture campaigns and television advertising. He has been recognized by the annual *Hollywood Reporter* Key Art Awards and the Chicago International Film Festival. His work is represented in *Outstanding American Illustrators Today*

vols. 1 and 2 (Rockport Pubs., 1984 and 1985). Contact: (805) 376-2291

Seymour **Chwast** is a founding partner of the celebrated Pushpin Group. His illustrations have been exhibited in major galleries and museums around the world including the Louvre. *IDEA*, Japan's leading graphics arts magazine, published a complete issue on his work, and he is the recipient of the coveted St. Gauden's Medal from his alma mater, Cooper Union. His book, *The Left Handed Designer* (Abrams,1985), is a classic in the field of illustration.
Contact: (212) 674-8080

Joseph **Ciardiello** has received numerous awards for his magazine and book illustrations, including a silver medal from the Society of Illustrators. His work has been represented in many annuals and exhibits as well as in *200 Years of American Illustration* (Random House, 1977), and *Art of Survival* (Doubleday, 1989). He has also been featured in *IDEA*, *HOW*, and many other magazines.
Contact: (718) 727-4757

Bob **Clarke** received his MFA from Rochester Institute of Technology in 1974. His fifteen years of experience include an extensive background in computers and video. In 1992 he won both Addy and Tell Awards. Contact: (716) 248-8683

Alan E. **Cober** is the recipient of over 300 awards, including the Artist's Guild's Artist of the Year Award. He considers himself to be a visual journalist and has worked for every major magazine in the United States and Canada. He has illustrated 35 children's books and is a founding member and president of the Illustrator's Workshop. In 1988 he was a visiting professor of art at SUNY, Buffalo. Contact: (914) 941-8696

Ron **Coddington** pokes fun at politicians and others in Washington, DC. He earned his BFA in illustration from the University of Georgia and is on staff at *USA Today*. His caricatures have been recognized by the Society of Newspaper Design and are part of the Knight-Ridder/Tribune Network. Contact: (703) 698-8923

Raul **Colón** quit his steady job and moved to New York to start his free-lance career in 1988. He has won many awards including the *Annual Reports* 5 award for best

illustration (1990). His work includes editorial, corporate, and book cover illustration. Contact: (914) 639-1505

Chris **Consani** was graduated with honors from Art Center College of Design. His work has appeared in a Society of Illustrators Exhibition and *Outstanding American Illustrators Today* (vols. 1 and 2 (Rockport Pubs., 1984 and 1985). He has received two Maggie Awards and some of his many clients include Capitol Records, Disney Pictures, Bantam Books, Miller Brewing Company, and McDonalds.
Contact: (310) 546-6622

David **Cowles**' first job in art was with the Rochester *Democrat Chronicle* in 1983. His definitive style is structured around simplified geometric design. His symmetrical abstractions are featured in such magazines as *Esquire*, *Rolling Stone*, *Entertainment Weekly*, *Us*, and *Playboy*, and he currently teaches illustration at Rochester's Monroe Community College.
Contact: (716) 381-0910

Kinuko Y. **Craft** was born in Japan, studied at the Art Institute of Chicago, and became a full-time illustrator in 1969. her eclectic and conceptual approach has won her many prizes and numerous prestigious clients as well. She was given a one-woman show at the Society of Illustrators and won their coveted Hamilton King Award in 1987.
Contact: (203) 542-5018

John **Craig** is a collector, country man, and collage artist. He studied at Rochester Institute of Technology and the Art Institute of Chicago. He has built a life and a career out of his interest in collecting old postcards, labels, and creating classic collages. Contact: (608) 872-2371

Tom **Curry** has worked as a designer, illustrator, and art director for a variety of design shops, ad agencies, and publishing houses. In 1979 he formed Sagebrush Studio in Austin, Texas, and soon joined forces with two partners to create Curry and Associates, a full-service ad agency.
Contact: (512) 444-8780

Alicia **Czechowski** illustrates regularly for the *New Yorker*. Her work has been exhibited extensively in the United States, Japan, and Germany. Rep: The Pushpin Group (207) 773-8775

Herb **Davidson** was graduated from the Art Institute of Chicago in 1956 and has had exhibits in galleries and museums around the world. He is listed in *Who's Who in American Art* (Bowker) and his insightful portraits are regularly seen in *Playboy*.
Rep: Wadie Galleries (505) 820-6728

Paul **Davis** is an American artist whose paintings have been featured on the covers of most major magazines, and in one-man exhibitions in museums and galleries throughout the United States, Europe, and Japan. He has had retrospectives at the Tokyo and Kyoto Museums of Modern Art and at the Centre Georges Pompidou in Paris. Contact: (212) 420-8789

Georganne **Deen**'s work has never been commerical enough to win design awards, but it has influenced an entire generation of illustrators. Her work has appeared in *FACE*, *IDEA*, *Vanity Fair*, *Esquire*, *Cannibal Romance*, and numerous record covers, fanzines, anthologies, and exhibitions around the world. Contact: (213) 665-2700

Robert **de Michiell**'s career as a caricaturist began when he was voted "class artist" in high school. After graduating from the Rhode Island School of Design in 1980, he headed to New York and has been busy ever since, doing humorous likenesses for such magazines as the *New Yorker*. Contact· (212) 769-9192

Blair **Drawson** studied at Ontario College of Art in Canada and moved to California in 1966 to illustrate children's books. His illustrations have appeared in magazines such as *Esquire*, *Playboy*, and *Psychology Today*. He describes his work as "satiric" and was influenced by 19th-century printmaker Hokusai. Contact: (416) 693-7774

Michael **Dudash** was a staff illustrator for McGraw-Hill Publishing. He has written articles for the *Artist's Magazine*, guest lectured at the Rhode Island School of Design, and has completed over 500 paintings and assignments since 1978. He lives and works in Vermont with his wife and three children.
Contact: (802) 496-6400

Rod **Dyer** founded his graphic design company in 1967 and is a founding member of the Museum of Contemporary Art in Los Angeles. He is on the advisory board of the American Institute of Graphic Arts

and has published four books. One of his record album cover designs was listed by *Rolling Stone* magazine among the top 100 of all time. Contact: (213) 655-1800

Mark **English** was graduated from the Art Center School of Design in Los Angeles, and for 15 years was a leading illustrator in New York, doing covers for *Time, TV Guide*, and the *Atlantic*. In 1969 he was named Artist of the Year by the New York Artist's Guild and he was elected to the Illustrators Hall of Fame in 1983. Contact: (816) 781-0056

Jim **Evans** calls himself a "media archaeologist." His fascination with the dominant role the media plays in our culture has led him to produce, in alliance with Mirage Editions, hundreds of limited edition monoprints of such celebrities as Elvis Presley, Marilyn Monroe, Marlon Brando, and James Dean. Contact: (310) 399-3834

Teresa **Fasolino**'s sumptuous artwork has graced the covers of numerous best-selling books, magazines, and annual reports. Her paintings have been featured in major art annuals. She has won medals from the Society of Illustrators and is represented in many private collections throughout the world. Rep: The Newborn Group (212) 421-0050

Linda **Fennimore**, a Julliard School graduate, turned from music to art in 1975. Her portraits and other illustrations have appeared on *Time* magazine's cover, Broadway and movie posters, record jackets, and books that range from Stephen King's *Pet Semetery* (Doubleday, 1983), to Victoria Holt romances. The Society of Illustrators mounted a one-woman show of her work in 1979. Contact: (212) 866-0279

Mark A. **Fredrickson** graduated from the University of Arizona in 1980. His intensely dramatic and wildly energetic illustrations have won him awards from *Communication Arts,* the Society of Illustrators (gold medal), *Print* magazine, *Graphis,* and many other national publications and competitions. Contact: (602) 722-5777

Bernie **Fuchs** is one of Americas most admired graphic artists. He is in constant demand for his sports images and has done many covers for *Sports Illustrated*, TV

Guide, and the *New Yorker*. The Society of Illustrators has given him over 100 awards and inducted him into their prestigious Hall of Fame in 1975. Rep: Harvey Kahn (201) 467-0223

Nicholas **Gaetano** has gold and silver awards from the New York Art Directors Club as well as numerous other prizes. He has done work for most of the top corporations, magazines, and publishers and has been featured in *Air Brush-Action, Novum, Designing with Illustration,* and *Two Hundred Years of Illustration* (Random House, 1977). Rep: Harvey Kahn (201) 467-0223

Joe **Garnett** has been a free-lance illustrator in the Los Angeles area since 1969. His work has appeared in *Graphis, Communication Arts* magazine, *Psychology Today, Rolling Stone*, and others. He has had one-man shows in Canada and Los Angeles and has done numerous album covers and movie posters. Contact: (213) 254-3549

Gerry **Gersten** is a world renowned humorous illustrator, whose crafted caricatures "exaggerate . . . yet remain kind." His work has appeared in *Esquire, Harper's, McCall's, Sports Illustrated, Time, Newsweek, Money*, and many other major publications. He is the recipient of the coveted Augustus St. Gaudens Award for outstanding professional achievement in art. Rep: Harvey Kahn (201) 467-0223

Robert **Giusti** was graduated from Cranbrook Academy and worked in New York as a graphic designer, art director, and teacher at the School of Visual Arts. A recipient of many awards, his work can be found in almost every graphic and art publication. He shares a studio in the woods of Connecticut with his wife, Grace, and their dog, Olive. Rep: The Newborn Group (212) 421-0050

Milton **Glaser** was co-founder of Pushpin Studios and is now president of Milton Glaser Inc., a multi-disciplinary firm located in New York. He has won hundreds of awards, was creative director for *New York Magazine*, teaches at the School of Visual Arts, is a trustee at Cooper Union, and has had a one-man show at the Museum of Modern Art. Contact: (212) 889-3161

Josh **Gosfield** is a fine artist and illustrator. He has had several one-man shows in New York City and Los Angeles. Contact: (212) 254-2582

Stan **Grant** has, in his own mind, become the modern-day John Singer Sargent, zooming past many others who aspire to such lofty plateaus. To know him is to leave him alone. He believes that his soul will be the world's property when his dream is finally understood. Until then, just let him dream. Contact: (818) 792-8555

Robert **Grossman**'s "Zoo Nooz" comic strip was one of the delights of *New York Magazine* and *Rolling Stone*. His caricatures have appeared on the covers of *Time, Newsweek*, and *Forbes*, and his cartoons have graced the pages of the *Nation*, and the *New York Times*. His animated short, "Jimmy The C," was nominated for an Academy Award. Contact: (212) 925-1965

David **Grove** is an illustrator whose work is commissioned by a wide range of corporate, advertising, film, and publishing clients. Originally from Philadelphia, he began working as a free-lance illustrator in France and England. His work has won numerous awards and has been exhibited in San Francisco, Los Angeles, New York, Paris, and Tokyo. Contact: (415) 433-2100

Kunio **Hagio** attended The Art Institute of Chicago and the Chicago Academy of Art. He rose to national prominence as an illustrator while working at *Penthouse* magazine. Kunio has won many prestigious awards and his work has been seen in most national and international magazines. He lives and works in Chicago with his wife and business parter, Paulette. Rep: Randy Pate (805) 529-8111

Philip **Hays'** career began in New York in the late 1950s where he worked primarily in the editorial and music industry. Since 1978 he has been chairman of the illustration department at Art Center College of Design in Pasadena. The list of his clients and exhibitions, is extensive, and his awards include silver and gold medals from the Society of Illustrators. Contact: (818) 584-5092

Robert **Heindel** gets his inspiration from the elusive world of dancers and seeks to capture the physical and emotional im-

mediacy of a body in motion. His "Obsession of Dance" (1985) exhibition led to his paintings for *Cats* and *Phantom of the Opera*. He has had numerous solo exhibitions and is represented in private collections around the world.
Contact: (203) 261-4270

Mark **Hess** has painted many postage stamps (voted best in 1989), *Time* and *Newsweek* covers, annual reports, book jackets, and advertising campaigns. His awards number in the hundreds and his paintings and prints are in collections worldwide. His work has been featured in most major art annuals throughout the past fifteen years.
Contact: (914) 232-5870

Richard **Hess** was a top designer and illustrator who died in August, 1991. He was widely exhibited in permanent collections and museums around the world and received hundreds of awards. He was a past director of the American Institute of Graphic Arts and the Illustrators Guild, and was a member of the Alliance Graphique Internationale.
Contact: Mark Hess (914) 232-5870

Bob **Hickson's** illustrations have appeared in magazines and on film posters and record albums for the past twenty years. He has designed commercials for Levi's and *Rolling Stone* magazine, and illustrated titles for Japanese television. His billboards frequently grace L.A.'s Sunset Strip, and in 1985, he received a Cleo Award for best package design.
Contact: (213) 856-0505

Fred **Hilliard** went from being an ad agency creative director to full-time illustrator in 1980. Since then, he's appeared in *American Illustration*, The Society of Illustrators annuals, *Humor*, *Communication Arts*, *Graphis*, and a host of anthologies representing the graphics and advertising industries.
Contact: (206) 842-6003

Hank **Hinton** began his career doing comic books and gag cartoons, but has become equally versatile in print, posters, and animatics. His editorial illustrations have appeared in the *Los Angeles Times Book Review* since 1969, and he was named Illustrator of the Year numerous times by *Adweek/West*.
Contact: (213) 938-9893

Al **Hirschfeld**'s drawings of absolute simplicity and pure line are admired by collectors and art lovers around the world. His work is in the permanent collection of every major museum, and in 1991 he became the first artist in history to have his name on a U.S. postage stamp booklet. He is the author of the book *Hirschfeld: Art & Recollections from Eight Decades* (Scribners, 1991). Rep: Margo Feiden Gallery (212) 677-5330

Van **Howell** studied at Boston University and taught art at Friends World College. He has won the silver award from the Society of Newspaper Design (1988) and Merit Awards from the Society of Illustrators, New York. His clients include Random House, the *Wall Street Journal*, *Newsday*, and various advertising agencies. Contact: (516) 424-6499

Curt **Hrabe** was graduated from Minneapolis College of Art and Design in 1980. His work was included in the Society of Illustrators 32nd Exhibition and he received a bronze award in the 1990 Chicago Midwest *Flash Magazine/Creative Print Advertising & Design* Award Show.
Contact: (708) 432-4632

Dave **Hudson**'s passion for painting faces has won him numerous awards including a place in the Society of Illustrators Student Scholarship Competition. Several years ago he left the fast-paced southern California art scene, but continues to work with a small clientele while enjoying life on the beautiful central California coast.
 Contact: (805) 528-7746

Robert **Hunt** was graduated from the Academy of Art College in San Francisco in 1981. He has won many awards including eleven gold and silver medals from the San Francisco Society of Illustrators. His work is featured in the books *The Greatest Illustration Show of America* (Tokumashoten, 1992) *and Art for Survival* (Graphis Press, 1992).
Rep: Randy Pate (805) 529-8111

Steve **Huston** was graduated as an illustrator from the Art Center College of Design. Since then, his style of figurative realism has allowed him to free-lance successfully in the entertainment and advertising fields for more than a decade.
Rep: France Aline (213) 933-2500

Barry **Jackson**'s early influences were *Mad* magazine, Marvel comics, and the psychedelic posters of Rick Griffin and M.C. Escher. After graduating from the Art Center College of Design, he became known in the entertainment industry for his distinctive posters and album covers. He was the conceptual designer on the Paramount movie *Cool World*.
Contact: (818) 769-7321

John **Jinks** has worked on a wide range of projects from album covers to broadway productions. His publishing and advertising clients include Gilbey's Gin, Microsoft, Touchstone Pictures, and Kohler, and his work can be seen in the Society of Illustrators and *Communication Arts* annuals as well as in *Print and Graphics* magazine.
Contact: (212) 675-2961

David **Johnson** was born in Detroit, Michigan. He graduated from a high school in Connecticut and since then he has been pursuing a career as a full-time illustrator right up to the present, although you might not have noticed, if you weren't paying attention. Contact: (203) 966-3269

Joel Peter **Johnson** received a BFA in painting and illustration from SUNY, Buffalo. He won first prize in *Print* magazine's 23rd Annual International Cover Design Competition and his work is frequently recognized by the Society of Illustrators, *Graphis* and *Communication Arts*. Contact: (716) 881-1757

John **Kascht** is known for seeing the world through "different eyes." He has free-lanced since 1987, and his illustrations have won him many awards including medals from the Society of Illustrators and *American Illustration* (1993). His large client list includes *Time*, *Entertainment Weekly* and *GQ*. He teaches illustration at the Corcoran School of Art. Contact: (202) 546-9527

Gary **Kelley's** illustrations have appeared in most major magazines including *Playboy*, *Rolling Stone*, and *Time*. The Society of Illustrators has honored him with 16 medals and his work has been featured in *Communication Arts* and *IDEA*. The National Football League commissioned him to create the program cover and poster art for the 1990 Super Bowl.
Contact: (319) 277-2330

Hiro **Kimura**, born in Japan, graduated with distinction from Art Center College of Design in 1981. His illustrations have won him numerous awards, including a gold medal from the Society of Illustrators. He is a member of Pushpin Associates, lives in Brooklyn with his wife Iku and their cat Benny, and likes to listen to jazz. Contact: (718) 788-9866

Stephen **Kroninger's** work has appeared in almost every magazine you can name. He designed the cover illustration for *50 Ways to Fight Censorship* (Thunder's Mouth, 1991), and has exhibited widely in New York at the New School for Social Research, La Boetie, and the Illustration Gallery. He has done album covers for Public Enemy, Midnight Oil, and Ahmad Jahmal. Contact: (212) 691-8696

Anita **Kunz** graduated from Ontario College of Art in 1978. She is one of Canada's most successful illustrators and has won many international awards, including the coveted gold medal at the National Magazine Awards. Her work has been seen in such magazines as *Rolling Stone, Esquire, Time, Newsweek, Playboy* and the *Atlantic*. Contact: (416) 364-3846

David **Lesh's** work has appeared in *Graphis, Print, Communication Arts* and New York Art Directors Club exhibitions. His conceptual pieces have been used by Apple, IBM, Swatch, and many other corporate clients, and the Society of Illustrators has awarded him two silver medals. He lives in Indianapolis with his wife Vicki, and sons David and Joe. Contact: (317) 253-3141

Tim **Lewis** attended The School of Visual Arts, worked for Young and Rubicam and, under the guidance of Milton Glaser and Seymour Chwast at Pushpin Studios, he graduated to free-lancer status in 1969. He now keeps busy doing editorial art for magazines and newspapers and spends most of his creative juices on corporate work. Contact: (718) 857-3406

Ron **Lieberman** began his art career in 1970 as an editorial illustrator for *Long Island Newsday* and soon gained a reputation for his Off-Broadway and Broadway theater posters. He has awards from the Art Directors Club of New York and *Print magazine* and teaches illustration and design at The School of Visual Arts in NYC. Contact: (212) 947-0653

Overton **Loyd** is best known for his two year stint as house artist on "Win, Lose or Draw." He toured with musician George Clinton as staff designer, and has done movie posters, and album covers. He created the comic strip "No Joke" for *URB Magazine* and his work was exhibited in the show "Black Ink" at the Cartoon Art Museum in San Francisco. Contact: (310) 470-7414

Rich **Mahon** has worked for every major movie studio and has done advertising illustrations for all the top agencies in the United States, Japan, and Hong Kong, accumulating numerous awards. His art has been exhibited extensively and is included in the Absolut permanent collection. Rep: Rosemary Morales (213) 467-4674

Cynthia **Marsh** is an illustrator and small-edition printmaker. She is currently a professor at California State University, Northridge. Work from her studio, One Eye Open/One Eye Closed, has been exhibited throughout the United States, Japan, and Europe. Contact: (818) 789-5232

Marvin **Mattelson** graduated from the Philadelphia College of Art in 1969 and became a regular contributor to *New York Magazine*. His award winning work has been featured on magazine, book, and record album covers, as well as in advertising, packaging and corporate commissions. He teaches at the School of Visual Arts and is represented by his wife Judy. Contact: (516) 487-1323

Mark **McIntosh** graduated from the Art Center College of Design in 1987. As a free-lance illustrator, his style has been recognized with many regional and national awards. Some of his clients include, Sunkist, Pacific Bell, Paramount, McDonnell Douglas, and *Playboy* Jazz Festival. Contact: (717) 642-7445

Wilson **McLean** was born in Scotland and began his career in a London silk-screen shop. To date he has won every major illustrator's award in the United States including a Cleo, eight silver and four gold medals from the Society of Illustrators, and the coveted Hamilton King Award. His work is in the Smithsonian Institution, and his client list is extensive. Contact: (212) 473-5554

David **McMacken's** ideas and design capabilities are legion. His projects range

from movies and album covers to airline and beer campaigns. His gold and silver awards are many, and his particular penchant lies in his special jukebox/arcade/WPA/Deco pieces. Contact: (707) 996-5239

Richard **Merkin** studied painting and drawings at the Rhode Island School of Design. In 1963 he received the Louis Comfort Tiffany Foundation Fellowship in painting. Since 1986, he has been a contributing editor for *Vanity Fair* magazine. He has had over 25 one-man shows and his face can be found on the cover of the "Sgt. Pepper's Lonely Heart Club Band" album (back row, center). Contact: (212) 724-9285

Steve **Miller** is a graduate of the Art Center College of Design. His advertising clients range from Avis to Xerox, and his many clients include the National Football League and *Playboy*. He teaches at Palomar Community College in California. Contact: (619) 758-0804

Bill **Murphy** is principal of Murphy and Company. His accounts range from motion picture advertising, album cover design, and editorial design to consumer advertising and promotion. He was art director for *Vogue* magazine in New York, and then became the creative director for the Rod Dyer Group in Los Angeles before starting his own design firm in 1991. Contact: (818) 345-2432

Bill **Nelson's** artwork has appeared on the covers of more than 30 magazines, including *Newsweek, Time,* and *TV Guide*. His colored-pencil drawings have won him more than 100 national awards including two gold medals from the Art Directors Club of New York and two silver medals from the Society of Illustrators. Contact: (804) 783-2602

Craig **Nelson's** credits include commissions from several corporations including Toyota, MCA, the NFL, Fisher Price, Disney, and other major film companies. He taught painting and drawing for 17 years at Art Center College of Design and is presently co-chairman of the Department Fine Art at the San Francisco Academy of Art. Contact: (818) 363-4493

Ron **Netsky** is chairman of the art department at Nazareth College of Rochester, New York. His work has been featured in

such publications as *Historical Reflections* (Alfred Univ. Press, summer 1992,1994) and numerous exhibitions including "Political People" at the Memorial Art Gallery of the University of Rochester (1988). His prints are in several collections including the National Gallery of Art in Washington.
Contact: (716) 586-5237

Chris **Notarile** graduated from Parson's School of Design and illustrates everything from *TV Guide* covers and movie posters to celebrity portraits. He created 12 portraits of Marilyn Monroe for a series of collector plates, and his poster for *Gaby* won an award at the 1987 Cannes Film Festival. Rep: Mendola Artists Ltd. (212) 986-5680

David **Noyes** graduated from Pratt Institute in New York. His big break came with a cover commission for *Sports Illustrated*, and he has been sought after as an illustrator and teacher ever since. His client list includes major corporations, and his exhibitions, commissions, and awards are too numerous to list.
Contact: (215) 572-6975

Tim **O'Brien** graduated from Paier College of Art. His paintings blend a unique imagination and photo-real style to solve the illustration problems of advertising, publishing, editorial and corporate clients around the world. Samples of his paintings can be found in American Showcase directories. Rep: Peter & George Lott (212) 953-7088

Rafal **Olbinski** was born and educated in Poland. In 1982 he came to America and established himself as a successful illustrator and painter. His work appears frequently on the covers of magazines such as *Playboy, Omni,* and *Newsweek*. He has received more than 100 awards, and his paintings have been acquired by major collectors around the world.
Contact: (718) 575-0292

Jacqueline **Osborn** started her career in England. She worked as a fashion designer for Windsmoor of London before moving to California, where she became head illustrator for *Sunset Magazine*. Now a free-lancer, her style has attracted an impressive client list of corporate executives, celebrities, and politicians.
Contact: (415) 326-2276

Peter **Palombi** has an MFA from Chouinard Institute and is an illustrator/graphic designer with gold medals to his credit. He prefers to combine his design abilities with the art director's concept for graphic solutions, and believes in the theory, "The less there is to look at . . . the more there is to see."
Contact: (714) 883-8403

Dickran **Palulian** is a nationally known illustrator who has strived to maintain the edge in contemporary illustration. He believes the secret to a long and successful career is challenging yourself to be innovative on each new assignment. His clients have included many prestigious American, European, and Asian corporations. Contact: (203) 866-3734

C.F. **Payne** received his BFA from Miami University in Ohio and studied at the Illustrators Workshop in Tarrytown, New York. His clients include *Rolling Stone, Spy, Esquire, GQ,* and many others. In 1987 he won the Gold Funny Bone Award at the Society of Illustrators Humor Show. He has lectured nationally at many colleges and universities.

Robert **Peak**, recognized as one of America's most creative and prolific artists, did over 100 paintings for films that include *Superman* and *Camelot*. He illustrated 40 *Time* covers, 30 U.S. postage stamps, received eight gold medals from the Society of Illustrators, and received a special Key Art Lifetime Achievement Award from the *Hollywood Reporter* in 1992. He died in July, 1992.
Rep: Harvey Kahn (201) 467-0223

Everett **Peck** is internationally known for his offbeat cartoon style of illustration and has won numerous awards, including ten medals at the Society of Illustrators 1988 Humor Show. He created the TV show "Duckman," and is the founder and head of the illustration department at the Otis Art Institute of Parsons School of Design in Los Angeles.
Rep: Richard Salzman (415) 285-8267

Daniel **Pelavin** received his training in design and illustration in Detroit, Michigan. Since 1979, he has maintained a studio in New York City.
Contact: (212) 941-7418

Mark **Penberthy** graduated from Art Center College of Design in 1982 and for the past ten years has lived in New York City, working for editorial, book, and corporate clients. His work has been included in the Society of Illustrators annuals, *American Illustration, Print,* and *Communication Arts*. Contact: (212) 219-2664

Greg **Ragland** graduated first in his class from Art Center College of Design in 1982 and has done cover and feature work for most major magazines including *Money, Sports Illustrated, Time, Newsweek, GQ,* and *Fortune*. He has won Awards of Merit from the Society of Illustrators and *American Illustration #3* (1984).
Contact: (801) 645-9232

William **Rieser** is an artist/designer currently living in San Francisco. His work can be found in numerous publications, books, on CD's, and in movies. He is currently working almost exclusively on the computer. Samples of his work can be seen in *Fashion Illustration in New York* (Sato Pubs., 1988), and *Showcase*.
Contact: (415) 389-0332

Robert **Risko** began painting when he was nine. His abstract caricatures were featured regularly in Andy Warhol's *Interview* magazine and in 1983 he became a featured contributor to the newly resurrected *Vanity Fair*. Risko's "stars" have appeared on movie posters, video packages, record albums, on TV, and in some of New York's most prestigious galleries.
Contact: (212) 255-2865

Phil **Roberts'** illustrations have appeared in sports magazines, surfer publications, newspaper editorials and books. He is presently illustrating movie posters for clients like Paramount, Universal, and Warner Bros. He is also an oceanographic illustrator, aquatic theme park designer, and sculptor. Contact: (310) 374-2970

Irena **Roman** received her MFA in illustration from Syracuse University in 1987 and has worked for most major publications including the *Atlantic*, the *New Yorker*, and *Mother Jones*. She is an assistant professor of illustration at Boston's Massachusetts College of Art and resides with her husband John, who is also an illustrator.
Contact: (617) 545-6514

Ken **Rosenberg** is a free-lance illustrator working in Southern California. He specializes in advertising illustration and book covers. Rep: Joanne Hedge L.A. (213) 874-1661

Laurie **Rosenwald** graduated from Rhode Island School of Design in 1977 and started Rosenworld, Inc., a multifaceted design studio in New York. She has been represented in major publications, exhibitions, and collections, is a professor at the School of Visual Arts, and has won many prizes including the Society of Publication Designers' Silver Award. Contact: (212) 675-6707

Balvis **Rubess** was born in Toronto, attended the Ontario College of Art and is currently a free-lance editorial and advertising illustrator. He did the set design for the play *Tango Lugano*, had a solo show called "Death & Taxis" in 1990, has designed murals for the *Globe & Mail*, and was a drummer for the Electric Carrots. Contact: (416) 927-7071

Robh **Ruppel** attended the Art Center College of Design and the Art Institute of Southern California. Some of his clients include NBC, Castle Rock/Columbia Pictures, *Readers Digest*, *TV Guide*, Simon & Schuster, and Bantam Books. Fleeing city traffic, he currently resides in the midwest and longs for the days when painting was king. Contact: (414) 245-0953

Joseph **Salina** was born in Scotland and attended the Ontario College of Art in Canada. He has a kaleidoscope of commissions and a drawer full of dusty awards. He lists his interests as magaliths, naked nymphs, siamese twins, and his two wonderful children who he loves more than the sky. Contact: (416) 699-4859

Kazuhiko **Sano** was born in Japan, received a Merit Scholarship to the Academy of Art College in San Francisco, graduated with a master's degree in 1981, and has taught there since 1983. He has many major corporate clients and has won the *Hollywood Reporter* Key Art Award and other awards from *Print* magazine and the Society of Illustrators. Rep: Randy Pate (805) 529-8111

Ward **Schumaker** graduated approximately 500 years ago from the University of No. Where. In 1991 a book of his drawings, *All My Best Friends Are Animals,*

was published by Chronicle Books. He works 23 hours a day out of his studio in San Francisco's North Beach, rising occasionally from his board to spit through the windows at passers-by. Contact: (415) 398-1060

Daniel **Schwartz** received his BFA from Rhode Island School of Design and has been exhibiting in major galleries and museums, winning awards such as the Benjamin Altman Prize for figure painting. He taught drawing and painting at Parsons School of Design and the School of Visual Arts and has been giving private classes in painting for the past 25 years. Contact: (212) 533-0237

Bill **Sienkiewicz** has had a major impact on the field of comic books with his innovative use of multi-media techniques and his storytelling approaches. He has won awards and critical acclaim in the United States and abroad and has exhibited his work worldwide. Rep: Harvey Kahn (201) 467-0223

Burt **Silverman** attended Saturday art classes at Pratt Institute at the age of nine. His career as an illustrator started in 1961 when he did covers for *Sports Illustrated*. His illustrations have appeared in *Time*, *Life*, *Fortune*, *Newsweek*, and the *New Yorker*. In 1990 he was elected to the Hall of Fame of the New York Society of Illustrators. Contact: (212) 799-3399

Greg **Spalenka** graduated from the Art Center College of Design. His socio-political illustrations have appeared in most major American magazines, including *Sports Illustrated*, *Newsweek*, *Playboy*, and *Omni*. He received both gold and silver medals from the Society of Illustrators, and his work has been seen in *American Illustration* and in several *Communication Arts* annuals. Contact: (818) 992-5828

Marcia **Staimer** graduated with a BFA from Syracuse University. She was staff illustrator for the *Miami Herald* from 1979 to 1988 and is currently a senior illustrator for *USA Today*, specializing in caricature and humorous illustration. Her work can be seen in *The Complete Book of Caricature* (North Light, 1991). Contact: (703) 276-5232

Dugald **Stermer**, a graduate of UCLA, served as art director for *Ramparts* magazine from 1964 to 1970. He designed the official medals for the 1984 Olympic Games, did *Time* covers, wrote and illustrated *Vanishing Creatures* (Lancaster-Miller, 1980), won gold and silver medals from the New York Art Directors Club, and is on the board of the American Institute of Graphic Arts. Contact: (415) 921-8281

David **Stevenson** is a Northern California illustrator who was trained as a graphic designer. He often adapts his illustrative style to fulfill his creative requirements and those of many top art directors and designers. Contact: (707) 447-5720

William **Stout's** work has been exhibited at the Smithsonian Institution, the Royal Ontario Museum, and the British Museum. He is an internationally known motion picture production designer and comic artist. His depictions of life in Antarctica will be used to establish it as the first World Park. Rep: France Aline (213) 933-2500

Drew **Struzan** is a world renowned portrait painter whose art is sought after by major collectors such as Steven Spielberg, Paramount Pictures, and Disney. Some of his classic commercial pieces include the cover of Alice Cooper's "Welcome To My Nightmare," and the posters for *Star Wars*, *ET*, and the Indiana Jones series. Contact: (818) 578-7291

Mark **Summers** is a Canadian illustrator whose portraits have appeared in the the *New York Times Book Review* since 1985. Other clients include the *New Yorker*, the *Atlantic*, *Time*, and Barnes and Noble. He won the gold medal (book category) from the Society of Illustrators in 1990. Rep: Richard Solomon (212) 683-1362

David **Suter** dropped out of the Corcoran School of Art in Washington, DC after two months in 1970. Since then his work has appeared in numerous publications around the world, including the *Progressive* and the *American Spectator*. Contact: (516) 267-8507

Robert **Tanenbaum** graduated with a BFA from Washington University in St. Louis and began specializing in portraiture. He has been commissioned to paint many well-known people and is one of only 22

portrait artists certified by the American Portrait Society. He is also a full member of the National Watercolor Society. Contact: (818) 345-6741

Dahl **Taylor** has illustrated for the pages of *Reader's Digest, McCalls, Forbes, TV Guide*, and many others. He also has several Broadway posters to his credit. His series of paintings, "Native New Yorkers," hangs permanently in the New York State Museum in Albany. Rep: Vicki Morgan (212) 475-0440

John **Thompson** graduated from Miami University of Ohio in 1962. As a painter and illustrator, his work has been included in the Society of Illustrators annual exhibitions every year since 1975. His many selected group shows include "200 Years of American Illustration," and he is an adjunct professor of art at Rutgers University. Contact: (201) 865-7853

Richard **Thompson** started drawing the day he was born and is still at it. His drawings have appeared in most major publications including the *Washington Post, National Geographic, Ms.*, and *Yankee.* He has won numerous awards, taught cartooning, and has lectured at the Smithsonian Institution. Contact: (301) 948-3732

Garry **Trudeau** received both his BA and MFA from Yale University. His well known "Doonesbury" comic strip currently appears in nearly 700 newspapers around the world, and his work has appeared in numerous publications and exhibitions. His is the first comic strip to win a Pulitzer Prize for editorial cartooning, and he wrote and co-produced HBO's critically acclaimed "Tanner 88." Contact: (212) 721-5075

Jack **Unruh** is well known for his artistic celebrations of nature. He has received a cache of prizes, including more than 50 Awards of Excellence from the Society of Illustrators. His illustrations have appeared in myriad publications including *Field & Stream, Outdoor Life,* and *National Geographic.* Contact: (214) 748-8145

Sam **Viviano** has been a full-time freelance illustrator since 1976. Best known for his contributions to *Mad* magazine, he has had his work featured in the annual

Society of Illustrators exhibition as well as its Humor Show. He is a faculty member of the School of Visual Arts and Pratt Institute. Contact: (212) 242-1471

Brent **Watkinson** grew up in the Ozark Hills and received his BFA in fine art from Missouri Southern State College in 1982. He is a member of the NASA Fine Arts Team and has had five pieces in the Society of Illustrators' exhibitions. Rep: Joanne Hedge (213) 874-1661.

Stan **Watts** attended the University of Oklahoma, where he was the staff cartoonist for the *Daily Oklahoman* and for the yearbook. He apprenticed at the Sketch Pad Studio in Texas and moved to Los Angeles in 1976. He now operates Dustbowl Design Inc. and has won many prizes, including two Grammy nominations and a Key Art Award. Rep: Tom Cormany (213) 578-2191

Don **Weller** is founder of the Weller Institute for the Cure of Design. He has won many awards, including gold medals from the Art Directors Club of New York, plus a Lifetime Achievement Award from the Los Angeles Society of Illustrators. His books, *Park City* (Weller Institute, 1984) and *Seashells and Sunsets* (Weller Institute, 1986), were both acclaimed by the American Institute of Graphic Arts. Contact: (801) 649-9859

Ed **Wexler** is a graduate of Cooper Union School of Art. He worked as an animator before free-lancing as an illustrator and cartoonist. His illustrated monthly caricature page in *California Magazine* featured deadly caricatures of show business and political celebrities. His advertising client list includes MGM, CBS, and Pepsi. Contact: (818) 888-3858

Charlie **White III's** eclectic career includes work in animation film, set design, trade/fine art shows, and illustration. In 1991, he founded OLIO, a collaborative of graphic artists, set designers, architects, writers and fine artists. OLIO projects include Tokyo Disney, MCA City Walk, and Treasure Island at the Mirage Hotel. Contact: (310) 452-1912

Kim **Whitesides** received a BFA from the Art Center College of Design. His work is often seen in *Time, Playboy, Rolling Stone, Redbook Magazine,* and *Texas Monthly,* and is part of the Paper Moon

Graphics product line. He has had over 20 art exhibitions in major galleries across the country and currently lives in Park City, Utah. Contact: (801) 466-0209

Ren **Wicks** has been prominent in the illustration field for the past 40 years. He was president of the Society of Illustators of Los Angeles and co-founder of the American Society of Aviation Artists. He has done six postage stamp designs and is now working for NASA on a painting of the space shuttle "Endeavor." Rep: Rosenthal Represents (310) 390-9595

Michael **Witte** was editor of the *Tiger*, Princeton University's humor magazine, until he graduated in 1966. Since then, his drawings have appeared in most major publications such as *Time*, the *New Yorker*, and *Spy.* He lives in South Nyack, New York with his understanding psychologist wife Sally, three sons, and two dogs. Contact: (914) 358-9095

Dave **Woodman** is a working animator for Disney Studios. Among his freelance projects are the cover illustration for *The Hooterville Handbook: A Viewer's Guide to Green Acres* (St. Martin's, 1993) and Phyllis Diller's logo. He set aside his paint brush to sculpt the highly marketed Simpsons bendable figures for creator Matt Groening. Rep: Tom Cormany (310) 578-2191

Janet **Woolley** attended the Royal College of Art in London and has been a professional illustrator since 1977. She has won numerous prestigious awards including gold medals from both Benson & Hedges and the Society of Illustrators. Her work can be seen in *American Illustration* (1991) and *Communication Arts* annuals. Rep: Alan Lynch (212) 966-7840

James **Yang** has won numerous awards during his eight year career, and his distinctive images have appeared in newspapers and magazines around the world. His work has been published in *Communication Arts, Print* magazine, and *Graphis.* Rep: David Goldman (212) 807-6627

Acknowledgments

I am grateful to all those people who gave their time, energy, and good thoughts in helping me to put this book together. The project was a joy and a blessing from concept to completion.

My special thanks to all the perceptive and dedicated people at Journey Editions, especially Peter Ackroyd, president, who saw my vision and trusted that I would deliver the goods.

To all the talented and gifted artists in the book, I send my heartfelt thanks for their diligence, patience, and humor as they faithfully delivered their "stuff" on time, and who often thought of me as a mother hen, keeping an eye on my wayward brood as they tried to focus on mundane chores like gathering slides and transparencies, writing bios, having a photo made, or filling out permission forms.

My thanks go out to Walt Reed for delivering his very thoughtful and incisive introduction; to Terry Brown for his intelligent, thoughtful, and articulate foreword; and to all the art students at the Ringling School of Art and at Syracuse University who submitted their design ideas for the book. Congratulations to Michael Snyder for winning the book design competition for *This Face You Got.*

My wife Helene, on two blessed occasions, allowed me to assist her in giving birth to my sons. That miracle will always be a highlight in my life. I remember the incredible charged energy that pervaded the maternity ward. The place was alive with new creation and I haven't found anything that has ever come close to the elation of that miraculous experience . . . except giving birth to this book and the creation of a new literary "life." Now that the pain is over, I want to thank Helene for her continued support in being there for me in my "delivery room" and for helping to coax my "baby" into the world.

Many thanks to my boys Sky and Tysun for their love and laughter and to my brother Edward for his continued spiritual support.

My appreciation extends to all those hard working artists' representatives and a special thanks to Harvey Kahn for his extra care and concern. To Tom Cormany, Randy Pate, Richard Solomon, Alan Lynch, France Aline, Richard Salzman, Michele Morgan, Peter Lott, Pamela Korn, Vicki Morgan, Johanna Hedge, Sharon Drexler, J. Wagoner, Kathy Brown, Fran Siegal, Ellen Knable, Rosemary, Harlib, Mendola, and any others I may have overlooked.

I gratefully acknowledge the assistance of the following individuals: Lonnie Lardner, Jon Winokur, Thomas Rockwell, Cris Curry, Lucy Wilson, Ginny Martino, Marsha Terrones, Vickie Gold-Levy, Roddy McDowell, Mario Casselli, Tom Dunsmuir, David Howell, Bob Cavalo, David Reneric, Andy Eddy, David Leopold, Myrna David, Paulette Hagio, Charlotte Bralds, Margaret Bragg, Susan Curry, Anna Nelson, Judy Mattelson, and Jodi Watkinson.